Copyright

Three Lines Communication
First published in Australia in 2006
by Three Lines Communications
ABN 19 876 840 576
www.teppanexus.com

Author:
Jin Yaon Short

Show Economist:
Jin Yaon Short
Jay Jay Macalaguing

Food Economist:
Jin Yaon Short
David Tan

Photography:
Jin Yaon Short

Edited:
Jin Yaon Short
David Short

ISBN
978-0-646-97101-8

MW00560386

This book is dedicated to my wife Sofiya and to my
daughter Anna. My сонечко.

To my father and mother.
The pillars in my life. Thank you.

his is a wonderful time to be in Brisbane and experience a revolution
' the taste buds that Queenslanders are just freshly experiencing.
oday, a wide range of cusines are readily available for everyone to expe-
ence. There are so many dishes to choose from, Dishes from all over the
orld that is, today, plentiful in the streets of Brisbane. International cuisines
at my father's generation never had opportunity experience forty years
go. A city that was known as a small country city into a global city, cher-
hed by its locals. The types of food that Brisbane offers today represents
e growing cultural diversity this city is willing to share and exhibit.

very cuisine offers a unique experience, not just because the food pro-
des a distinct variety of taste, but also because it is prepared, cooked
nd eaten in different ways. An experience of culture we now can enjoy in
oundance of culture simply by eating.

he simplest and freshest dishes are often the best, they are easy to make
ut also because the basic ingredients often make the most difference in
rning simple food great. And thatís not all. How we experience what we eat
an turn a good meal into a memorable experience.

ften people would ask us what our profession is, as soon as we say
 Teppan-yaki cooking another question quickly pops up in their mind,
hat ís Teppan-yaki? For those who have never experienced this style of
ooking the nearest description would be that it is a stylist way of barbecue
ooking where the chef stands in front of people cooking up fresh vegeta-
les, juicy seafood and tender steak. And for those who have experienced
might be daunted by the way it is done. Well donít, because the concept of
his Teppan-yaki book is not far from that of the barbecue. Just like the two

basic things you need are a hot plate and a juicy piece of meat. If you've thrown a prawn on the 'barby' at a Saturday party, then your half way there. Easy peasy.

The teppan-yaki style is of Japanese origin, meaning iron plate cooking. Numerous restaurants claim that this art of cooking goes back more than one hundred years. It has been said that teppan-yaki originated in the homes by family cooking on small grills, eventually developing into an expressive art performed by restaurant chefs. Today we see chefs around the world practicing the art in elaborate ways of slicing, dicing chopping the eggs, the flambe and all the action teppan-yaki cooking can offer that no other fare can. For some, the entertainment is what they come for. But this not the only reason why they keep coming back. To put it simply, the food fresh and delicious.

Teppan-Yaki is an art. It may have evolved into an intricate tradition of barbecue show, but it did start in the household. This book aims to bring back the wholesome fun of family barbecuing. In this book, we will show you the basics in teppan-yaki cooking, the preparation of food, simple recipes that are easy to make and of course a few tricks illustrations for you show off at your next barbecue party.

This book offers another form of cooking that will accentuate the commonality of the people ís love for barbecue cooking. All through-out this book I will show you the different ways food can be cooked and presented using recipes common from around the world.

A Brief History in Japanese Cooking

e mid 19th century was the time Japan became ly exposed to the culture of foreign food. Lead American Commodore Matthew Perry, the legation of Japan's foreign trade policy in 1854 ened the self-isolated country to the modernization of Japan. As a result of this policy significant anges to the Japanese political, social and tural structure began. Japan learned new customs and adapted new methods to intertwine with eir own. Foreign produce influenced the method Japanese cooking. These produce were incorrated with the countryís washoku (Traditional panese food), which then developed into yo-oku (Foreign food). Consequently Japan commenced on fusing old tradition with new methods cooking.

course Japan traded with foreigners long be-e this period and has been influenced by oth-countries with its culinary diet. Tempura, for ample, is one of the country's staple dish but ve originated from Portugal during its trade with pan in the 16th century. The word Tempura was ost likely to have been derived from the Portu-ese word Tempora meaning ember days (Kazuko). is the American Free Trade however that Revo-ionized the taste buds of the Japanese people. fore the ports in Japan were opened for trade, pan's diet strictly consisted of vegetables and h. Zen Buddhism played an imported factor th this diet. The religionís profound respect for e is a significant reason for the scarce use of eat in Japanese meals (Kazuko).

The slaughtering of animals and eating meat was considered to be a sinful act and was banned by the Zen Buddhism sect, which highly influence the countryís culture (Kazuko). The impact of this ideology reflected the countryís diet. The philosophy of Zen, its simplicity, is visibly present with its presentation of meals such as sushi and sashimi. Although the basic ingredients used in Japanese meals are commonly used in Chinese food, the Japanese outcome in its taste and appearance are distinctly different (Kazuko). This is the Zen effect. The most significant change after the trade agreement was the inclusion of meat as part of the Japanese diet. A shrine to the first cow slaughtered for human consumption still stand at Shimoda Harbour (Kitao), symbolizing as a major change in Japanese culture and diet, which led to the development of yoshoku. The emperor himself ate meat at the beginning of the Meiji era (Kazuko). As a result, the general public enthusiastically followed perceiving it as fashionable.

While the development of washoku extended to new levels it still maintained its Zen approach in its method and presentation of cooking. Today beef

is widely used in Japanese food, the creation of such dishes such as Tonkatsu, Sukiyaki and Shabu Shabu are very popular and have crossed overseas to become one of the staples of Japanese meals.

As foreigners steadily arrived in Japan supplies to cater for the foreign diet was first met with difficulties in obtaining the right supplies (Kusama). At first the scarcity of supplies limited foreign gathering places to small diners provided by trading company ships arriving at the ports (Kusama). As time progressed diners, shops, restaurants and hotels were established to accomodate the increasing numbers of foreign traders.

Throughout the late 19th century sociable gathering places were built for western traders. Numerous establishments were opened serving dough-based confectionaries, such as pies, sweets and tarts (Kusama). Meanwhile wines, whisky and brandy were served in hotels and restaurants (Kusama). These novelties were met with great curiosity by the Japanese people, which inevitably spread.

In 1864, under the ownership of James Mixter, the Tycoon Hotel opened its doors not only to the general foreign public but to the Japanese as well (Kusama). The hotel prepared its food according to the seasonal climate and occasionally offered unusual delicacies for customers who desire them (Kusama). The opening of hotels such as the Tycoon Hotel is an example of cultural crossover of western food in Japan. Chefs from abroad were brought in to cater for the visitors. Foreign chefs that owned bakeries and restaurants employed Japanese staff to work under them, but as they themselves learned how to make these delicacies soon opened thier own (Kansai International P.R Promotion Office).

Through political transformation, the shift of power from the traditional rule of the Edo period to the rise of the Aristocrats in the Meiji Era introduced new products and ideas and inevitably influenced Japan socially and culturally.

Japan learned to cultivate these produce and formed its owned identity. Today we see Japan radically transformed its own food identity since it opened its borders. Today we see produce such as beef, coffee, wine, cheese etc. made to Japanese standard. In Kobe, the Tajima cow is raised particularly to suit Japanese taste. Fed with only the top quality grain Kobe beef is known for itís marbling in the meat and is famed as the most superior beef of the black haired cattle. The Camembert type Kobe cheese is made to be milder in its taste and smell than its European counter-part. Today Japan competes in the world market to sell these produce, adding more variety to what we eat.

Food is an important part of everyoneís life. The food that we eat, how chefs and cooks present them brings happiness to our lives especially when we experience our favourite meals and discover new ones. What we eat brings us pleasure. What we make satisfy our creative bones.

out the stainless steel:

eppanyaki table is the basis of Japanese style barbecue. It is
d the teppanyaki that people get to enjoy great food, fantastic
and a night of entertainment among friends. For people who
importance of the simple pleasures of a great night inn with
eople you value the most, a teppanyaki barbecue offers more
just a good meal for your friends but a chance to make an
ssion. I have cooked for many guests who would love to have
panyaki grill in their home but have been under the impres-
that to be able to cook teppanyaki takes years of training and
line – not necessarily. The first thing you have to learn in any
od of cooking is to learn how to control the heat where you are
ng on. If you have cooked on a barbecue before then you're
y to cook teppanyaki.
book familiarizes you about the flat surface barbecue and will
you new techniques to use when cooking on the table.
y you have to know how your teppan table works. As you are
e there are two kinds of power source that can be used, elec-
nd gas. Both power source function differently.

chefs use gas tables because they can distribute a stronger
at a minimum amount of time. Gas tables will have pilot lights;
ctions as a starter light in providing heat for the gas rims and
e rest of the table. Once the heat has been applied you have to
vare how fast your grill heats up. Most gas tables supply an ex-
dinary amount of heat. While there are no temperature controls
as, getting to know how gas heats up can be more beneficial, it
s you to control the heat at your own pace. As a result it allows
o cook your dish with better control.

ric:

cric tables are simpler to use. It has a temperature knob which
be set at your desired cooking leisure. All you have to do is turn
able and the coil underneath heats up the table. Electric tables
ever will take a bit longer to heat up than gas. While electric ta-
distributes a steady heat for cooking it will take some patience
anging the temperature of your teppan.

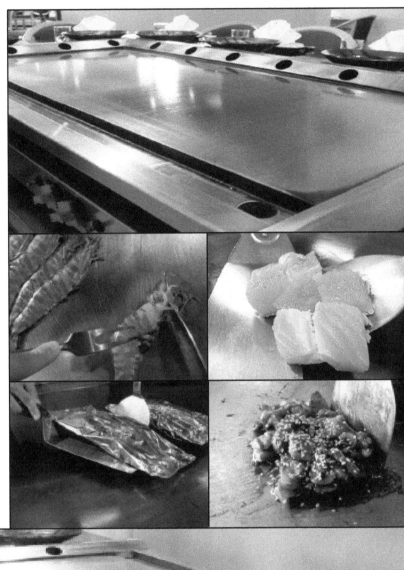

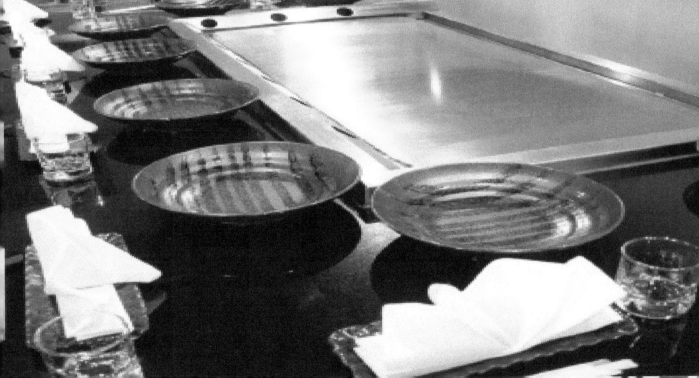

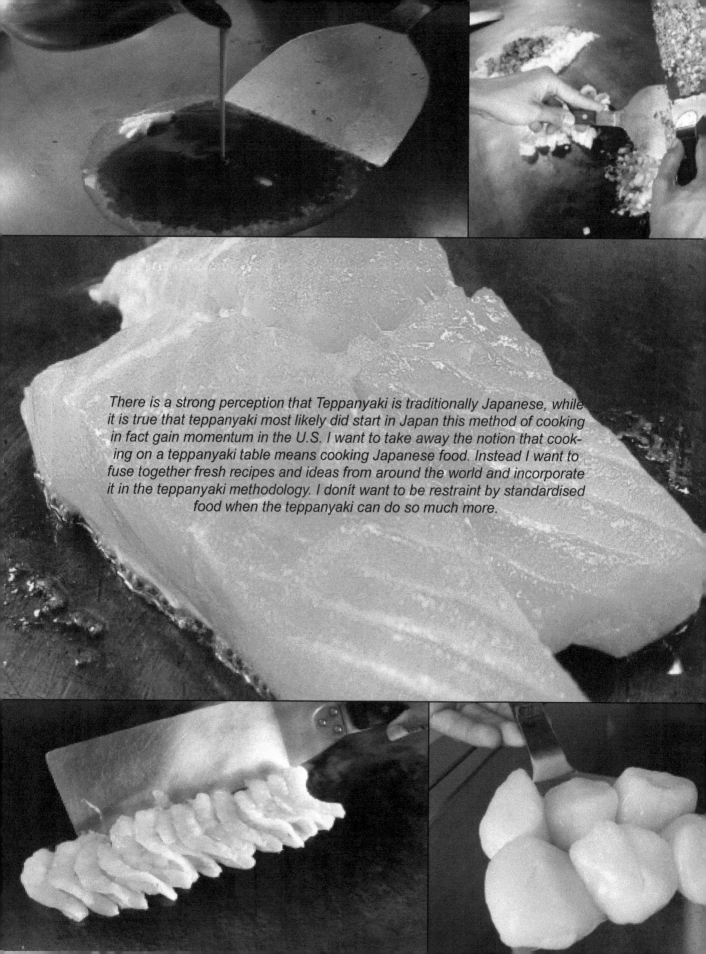

There is a strong perception that Teppanyaki is traditionally Japanese, while it is true that teppanyaki most likely did start in Japan this method of cooking in fact gain momentum in the U.S. I want to take away the notion that cooking on a teppanyaki table means cooking Japanese food. Instead I want to fuse together fresh recipes and ideas from around the world and incorporate it in the teppanyaki methodology. I donít want to be restraint by standardised food when the teppanyaki can do so much more.

Before we go on, there are some essential equipments that you will need to be able to cook the following recipes on the table. These utensils will make the dishes you choose faster and easier to cook.

Once you have had a good look at the photos in the following pages you will find that some of these utensils might be new to you. The Okonomi-yaki Spatula for example is traditionally a Japanese utensil. This pair of spatula is used for making Okonomiyaki, also known as Japanese pizza. More importantly this is a standard tool among teppanyaki chefs because of its manoeuverability in scraping and scooping on flat surfaces. If this is not available in your area, don't worry, you can always improvise with other equipments.

Although it might be ideal to use a pair of okonomiyaki spatula and get that oriental feel on your barbecue, a turner spatula accompanied by a fork will work just as well. It is widely used in teppanyaki establishments in the west. The fork and the turner spatula works very well in cooking fried rice. It allows you to flatten the clumps of the rice with the spatula and break the smaller clumps with a fork. It is also common for teppan chefs to

Knife & Fork

use both the turner spatula and okonomiyaki spatula at the same time. In addition, instead of a holster to hang on to your belt while you're cooking, a knife pouch is just as good. Cutting meat on the hot plate can blunt the edge of the knife very quickly. I have found that using a less valuable knife is just as good and easier to sharpen than a stronger, more expensive knife. The soft steel of the less expensive knife might blunt them quickly but they do sharpen just as fast using a stone or steel. It might be more useful leaving your prized knives on the chopping board and just settling for a more economical one. They work just as well if sharpen regularly.

The salt and pepper shakers and dredges are the teppanyaki chef's most used piece of equipment when it comes to tricks. There is a wide selection of shakers that are used by teppan chefs to play with, ranging from small dredges to tall wooden shakers. When it comes to cooking however, both types are used differently. The salt and pepper dredges are commonly used when there are a large number of guests because of the large amount of salt or pepper that can be sprinkled out. The wooden shakers are commonly used for a smaller number of guests. Make sure you have little things around your teppanyaki plate such as a wet cloth to wipe the

Okonomiyaki Spatula

Salt and Pepper Shakers

grill regularly and a bowl to hold sauces and eggs. As you turn the pages of this book you will see how these utensils are put to practical use.

There is one thing to remember in learning the basic teppanyaki skills and that is most of the tools used are an extension of your hands. Every time you turn, cut, sprinkle and pick up the food from the hot plate, what you're holding is an extension of yourself.

Teppanyaki chefs choose their equipment with care. This has a lot to do with comfort. The more comfortable you are with what you use, the better you cook. Chefs also like to have fun and chose equipment that makes them feel like an individual. You will notice that different teppanyaki chefs have made slight modifications to their equipment. It is important is to get comfortable with your tools and your cooking table. Having the right utensils helps make your practice perfect.

Spatula Turner

Meeting your personal chef

One of the most gratifying experience that I get from cooking teppanyaki is to se the satisfaction on my customers' faces. Unlike other working chefs and cooks c different culinary background, we get to meet our customers upfront and are able t interact with them. Teppanyaki chefs get to see first hand how their work is received. enjoy the simple plessure of seeing that my work and the food I produce is enjoyed b my guests.

Standing infront of a number of people can be a nerve racking experience for any one, especially for those who are just starting out. The feeling can be compared t a person making a public speech, except the normal expectation from us is to coo good quality food while entertaining customers. This can be a lot of effort for som chefs without any encouragement from their guests, especially when they have to coo in front of a hot barbecue table. So remember to cheer on the chef who is cooking fc you. All chefs have different personalities with different cultural background. It is a goo idea to know your local teppanyaki chefs when entering a restaurant so you find ou which chef is suitable for you.

Preparing ingredients for your barbecue

In any kitchen that I have ever worked in, a vital aspect to cooking a good meal is how well you prepare your ingredients. A good cook does not turn the fire on without first thinking what he/she will need in the kitchen to create the meal for those he wants to cook for. A good preparation will make it easier for you to work on that fabulous dish. So make sure you have everything you need before you start cooking and keep everything in reach. The simpler the recipe is the easier it is for the cook to learn about recipe. If any exotic ingredients do become part of that dish, it should be kept to a bare minimum to allow for the palate to experience that flavour. It's not often that we get a chance to cook, and in this busy lifestyle that we live in who really has time to create complex dishes that takes hours to prepare when all we really want is something enjoyable to make. Recipes should be straight forward and the ingredients should be easy to obtain.

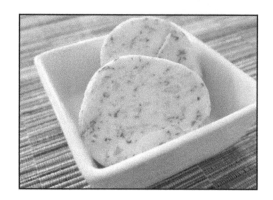

Garlic Butter

600g Butter
40g Garlic
15g Parsley
2tspn Soy Sauce

Take out butter and margarine and set to room temperature. Finely chop parsley. Crush garlic. Set aside.

Place softened butter in bowl and mix roughly. Add crushed garlic and chopped parsley. Mix again. Pour soy sauce and salt and mix until all ingredients have blended.

Lay glad wrap on a flat surface. Scoop the garlic butter and place on the bottom of glad wrap. Use spoon to roughly form a tube. Close each end of plastic wrap to reinforce tube. Roll tube from the bottom of plastic wrap towards the top.

Refregirate.

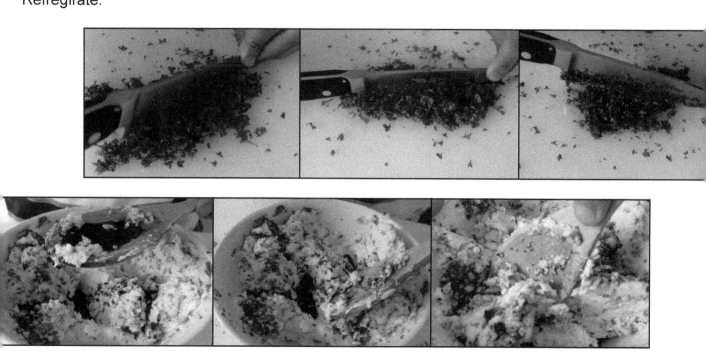

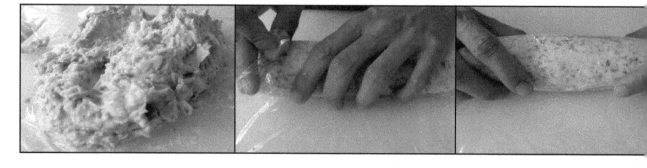

Vegetable Preparation

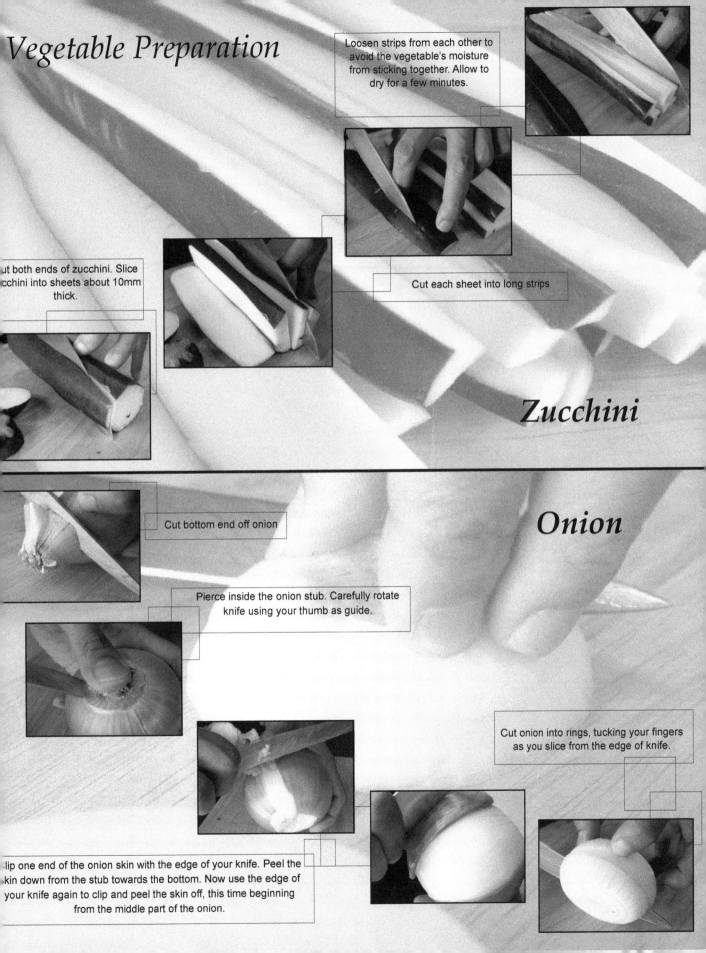

Loosen strips from each other to avoid the vegetable's moisture from sticking together. Allow to dry for a few minutes.

Cut each sheet into long strips

ut both ends of zucchini. Slice cchini into sheets about 10mm thick.

Zucchini

Onion

Cut bottom end off onion

Pierce inside the onion stub. Carefully rotate knife using your thumb as guide.

Cut onion into rings, tucking your fingers as you slice from the edge of knife.

lip one end of the onion skin with the edge of your knife. Peel the kin down from the stub towards the bottom. Now use the edge of your knife again to clip and peel the skin off, this time beginning from the middle part of the onion.

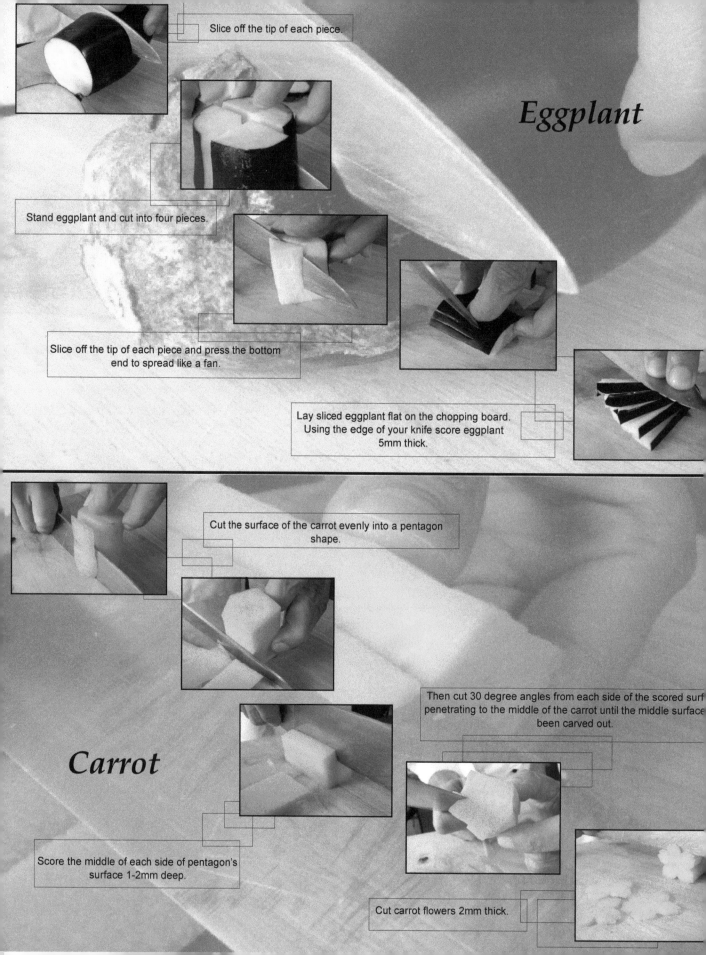

Eggplant

Slice off the tip of each piece.

Stand eggplant and cut into four pieces.

Slice off the tip of each piece and press the bottom end to spread like a fan.

Lay sliced eggplant flat on the chopping board. Using the edge of your knife score eggplant 5mm thick.

Carrot

Cut the surface of the carrot evenly into a pentagon shape.

Then cut 30 degree angles from each side of the scored surf penetrating to the middle of the carrot until the middle surface been carved out.

Score the middle of each side of pentagon's surface 1-2mm deep.

Cut carrot flowers 2mm thick.

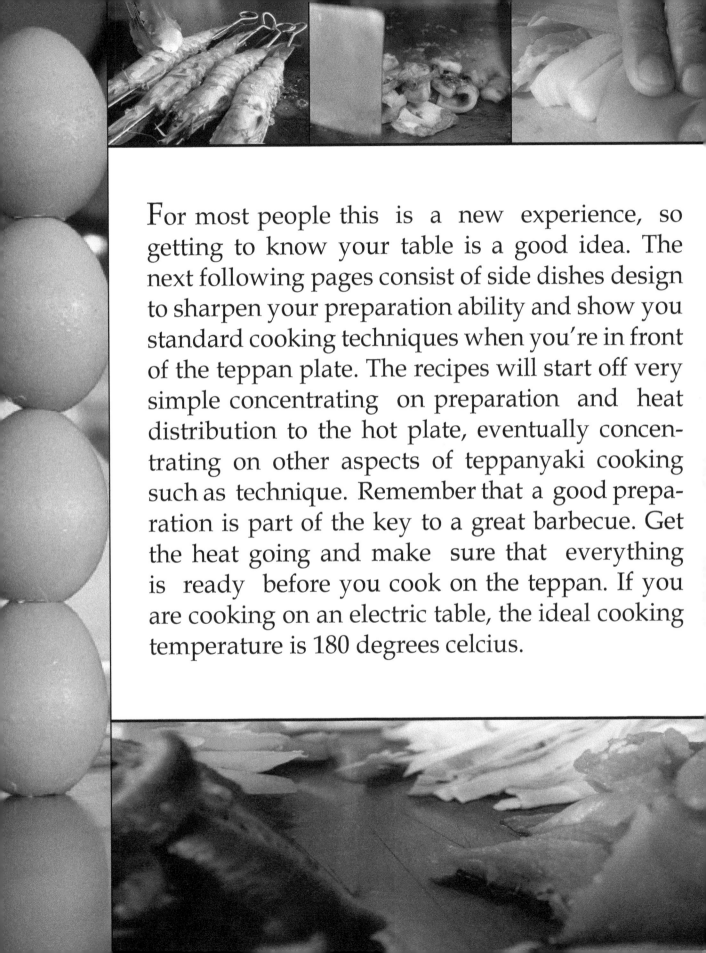

For most people this is a new experience, so getting to know your table is a good idea. The next following pages consist of side dishes design to sharpen your preparation ability and show you standard cooking techniques when you're in front of the teppan plate. The recipes will start off very simple concentrating on preparation and heat distribution to the hot plate, eventually concentrating on other aspects of teppanyaki cooking such as technique. Remember that a good preparation is part of the key to a great barbecue. Get the heat going and make sure that everything is ready before you cook on the teppan. If you are cooking on an electric table, the ideal cooking temperature is 180 degrees celcius.

Starters & Sides

Sea Salted Prawns

1kg Fresh King Prawns
Sea Salt (to taste)
1/2 Lemon Wedges

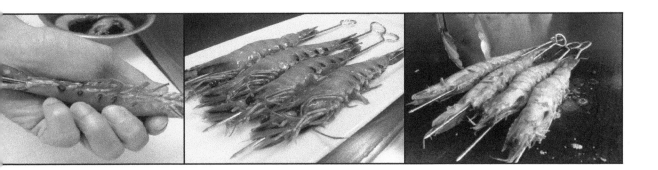

Preparation:

Cut the back of the prawn shell with scissors to loosen prawn meat. Devain prawns. Pluck most of the legs off the prawns before running the metal skewer along the bottom part of the prawn. (This will prevent the prawns from curling as they cook). Set skewered prawns on a plate. Sprinkle sea salt over both sides of the prawn shells.

On the Teppanyaki:

Heat the teppanyaki to a medium temperature level. Lay the salt covered prawns on the teppan. Cook for 10 minutes before turning over with a tong. Cook other side for 7 minutes until the shells become white and brittle. Pick up with tong and shake off excess salt. Allow the prawns to cool. Serve with lemon wedges.

Recommended dipping sauce:
Wasabi Mayonnaise
(Please refer to back of book)

"Let's start with something very simple. Sea salted prawn is an easy side dish to prepare with minimum effort to cook. This is to get you into a routine before we get you used to cooking on the teppanyaki plate. Because every barbecue heats up differently, this starter dish will get you used to how fast your hot plate heats up. The recipe is basic and traditionally Japanese."

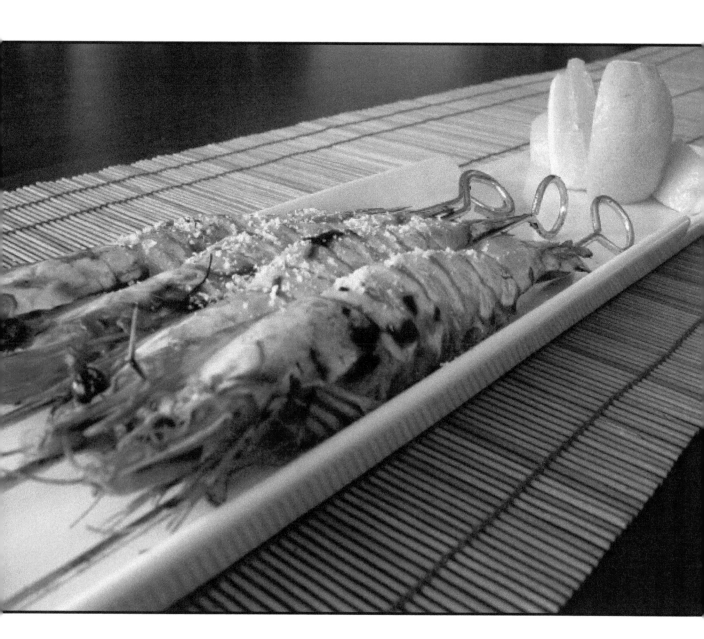

20ml Balsamic Vinegar
0ml tspn Dijon Mustard
0ml Mirin
20ml Olive Oil
Capsicum
Zucchini
/2 Eggplant
Shoots Asparagus
Bunch Coral Lettuce
Bunch Rocket Leaves
00g Parmesan Cheese

Mediterranean Salad

Preparation:
Cut capsicum, zucchini, eggplant and asparagus about 1 inch long. Cut tomato into four slices. Set vegetables aside in a tray. Place coral lettuce and rocket leaves in a bowl and set aside separately. In another container mix olive oil, Dijon mustard and balsamic vinegar to make dressing.

On the teppanyaki:
Heat teppan to high temperature. Splash a dash of olive oil. Spread oil over the heated teppan using a spatula. Stir fry sliced vegetables on the hot plate, constantly stirring for 2-3 minutes. Scoop off vegetables from the teppan. Mix vegetables with rocket and coral lettuce. Pour salad dressing over and serve before Mediterranean salad wilts.
Grate parmesan cheese over salad.

500g Squid
Black Peppercorn
6 clvs Garlic
20ml Oyster Sauce
10ml tspn Fish Sauce
5ml Sugar
10ml Soy Sauce
10ml Oil

Pepper Garlic Squid

Preparation:

Peel off excess sinew from the surface of the squid. Mix crushed peppercorn and garlic in a bowl. Add a tablespoon of oyster sauce, 1/2 tpsn fish sauce, 1 tspn sugar and 1 tspn of soy sauce. Stir until the sugar is dissolved.

On the Teppanyaki:

Turn on teppan to moderate heat. Spread vegetable over heated section. Place peppered squid and immediatley stir all sides of squid. Cut the Squid into 2 inch long and 1 inch wide. Pour sauce on the cooler side of teppan. Mix squid with sauce. Scoop and serve.

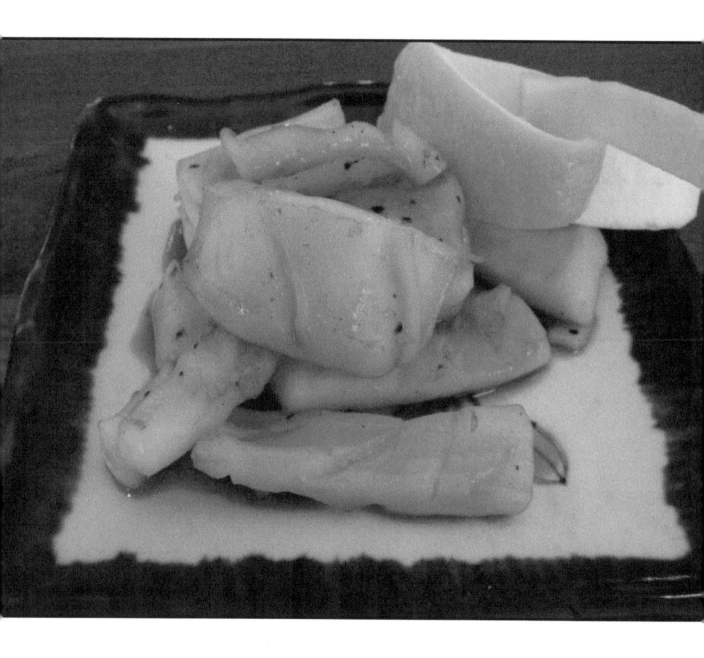

200g Chicken Thigh
1 Onion
1 Shoot Shallots

Yakitori Sauce:
50ml Mirin
50ml Sake
120ml Soy Sauce
60ml Sugar
1/2 Chicken Stock Cube

Chicken Yakitori

Preparation:

Mix mirin and sake together and bring to boil. Keep a fair distance from the boiling alcohol before lighting the mixed alcohol. The fire will start to consume the alcohol. Switch the fire to low level of heat once the fire extinguishes. Add soy sauce and sugar, stir until sugar has dissolved. Keep the heat to moderate temperature and simmer for about 5 minutes, allow the sauce to concentrate. Pour the sauce in a container to cool.
Cut chicken into bite size pieces. Cut shallots and onion 1 half inch long. Skewer chicken and vegetables right in the centre.

On the teppanyaki:

Heat teppanyaki table. Splash a dash of oil and spread it around the heated part of the grill. Lay the Yakitori and allow to cook for 3 minutes before turning over, the surface should be crispy brown. Allow the other side to cook the same way. Once both sides is cooked pour yakitori sauce on a cooler part of teppan, simmer for 2 minutes to further thicken the sauce.

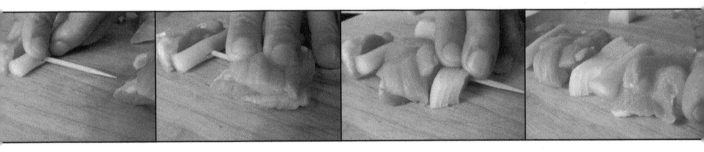

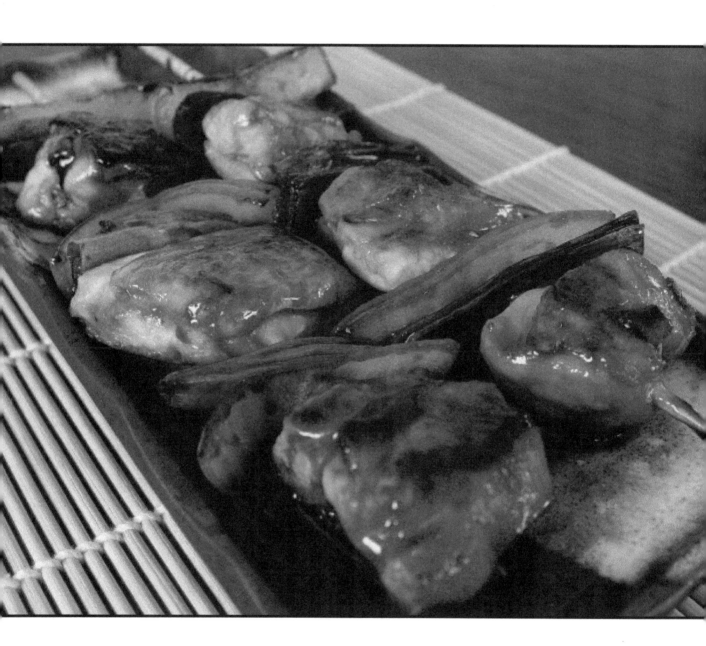

Teppanyaki Fried Rice

250 grms Prawns
1ltr Boiled rice
1 Shoot Shallots
1/2 Carrots
1 Onion
10ml Garlic Butter
20ml Soy Sauce
2 eggs
Salt & Pepper (to taste)

Preparation:

Dice onion, carrots and shallots. Mix all three vegetables in a container. Peel and devain the prawns, then butterfly them and set aside. Beat the eggs in a bowl and set aside. Put all these ingredients separately near the teppanyaki for easy reach.

On the Teppanyaki:

Splash a good amount of vegetable oil on the teppan. (1) Lay prawns with spatula on the heated teppan. Turn over after 2 minutes to cook both sides, push prawns aside on the cooler side of teppan to make room for the vegetables. (2) Saute vegetables with butter for 30 seconds, set on cooler edge of teppan. Cook scrambled eggs by pouring on oiled teppan and spreading it using your spatula (pages 32-33). Scrape and wipe off residue from the hot spot of teppanyaki plate. Splash more oil on the heat and spread again with spatula. (3) Lay rice on the hot plate, mix the rest of sauteed ingredients with rice. Sprinkle salt and pepper evenly over rice. Add soy sauce and butter last. Mix fried rice thoroughly using your spatula and fork to flatten clumps.

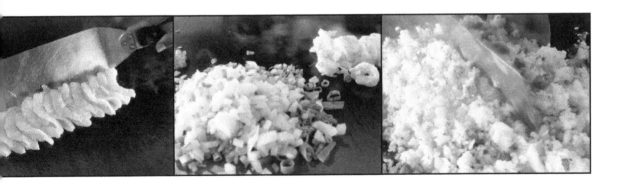

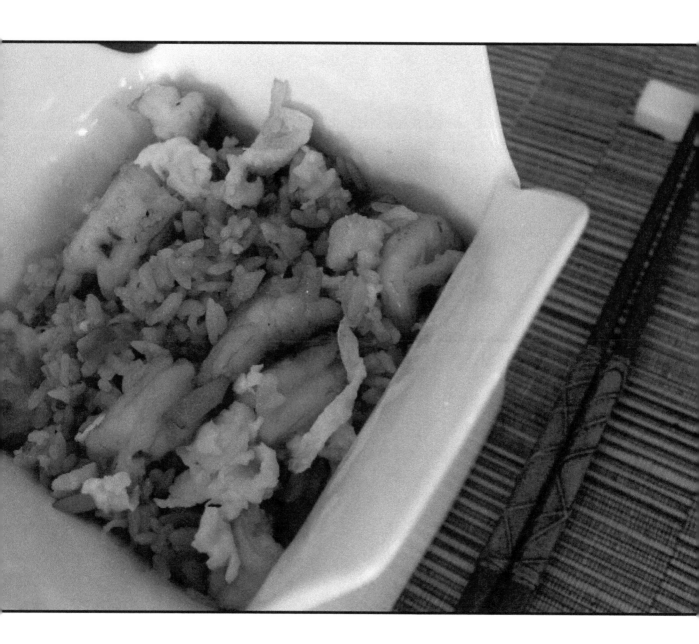

Rolling and cutting eggs

Pour scrambled egg on oiled part of grill.

Spread scrambled eggs with long spatula and Scrape one edge of the egg to loosen the bottom.

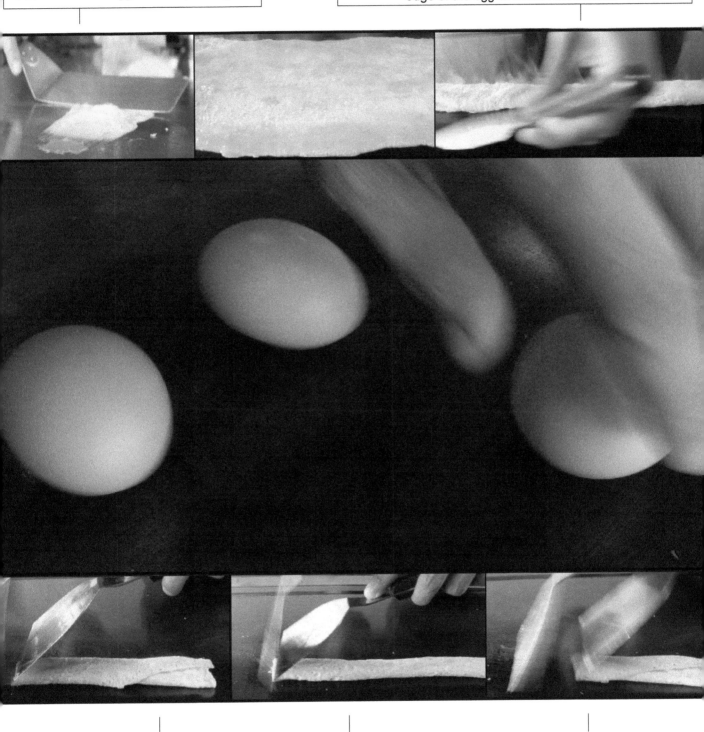

Face the spatulas on one edge of the rolled eggs. Beat the spatula facing outward vigorously using the spatula on the rear as your guide making a clanging sound.

Flip scrambled egg inward to form a line.

Teppanyaki

The simplicity of the teppanyaki method is intended to bring out the natural flavours of the meat chosen. Traditional method uses little ingredients, emphasizing more on the main feature of a dish and its complimentary dipping sauce. Teppanyaki takes away the distraction of complex ingredients and focuses more on the simplicity of cooking the dish to its succulent state. Teppanyaki expresses a unique art of cooking, not just limiting itself with the food but also the process. The form is characteristic of its preparation, presentation and knife skills. Teppanyaki has evolved to an advanced form of barbecue offering both pleasure to the palate and culinary fun. Some might say that the new teppanyaki cooking focuses too much on its entertainment value than the quality of its dish. A balance of both food and flare should exist in today's teppanyaki to create a proper equilibrium. The following pages offer fresh ideas to cook on the steel plate as well as traditional dishes. The method of cooking is just as important as the right amount of ingredients used in the recipe. Cutting, turning and stirring at the right moment guarantees the succulence of your chosen meat.

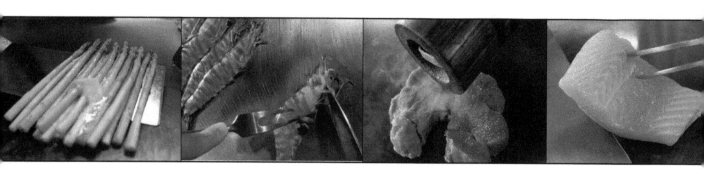

Yakisoba

150g Thinly Sliced Pork
600g Soba Noodle
3 leaves Cabbage
50g Bean Sprout
1 pc Green Bell Pepper
5 pcs Shitake Mushroom
1/2 Carrot
1/2 Sesame Oil
125ml Okonomiyaki Sauce
30g Grated Nori
30g Shaved Bonito
Salt & Pepper (to taste)

Preparation:

Boil soba noodles for 2 minutes, drain water after boil and set aside. Cut pork into thin slices. Cut cabbage, shitake mushroom, carrots and bell pepper into thin slices. Set aside.

On the Teppanyaki:

Splash a dash of sesame oil on the teppan. Spread oil with spatula. Throw vegetables and cook for 1-2 minutes constantly mixing. Add noodles next and mix with stir-fried vegetables. Sprinkle with salt and pepper then pour okonomiyaki sauce. Use spatula to mix everything until the sauce is evenly distributed with the noodle. Now simply scoop the noodle with your utensil and place it on a plate. Sprinkle grated nori and shaved bonito on top of the noodle. Serve.

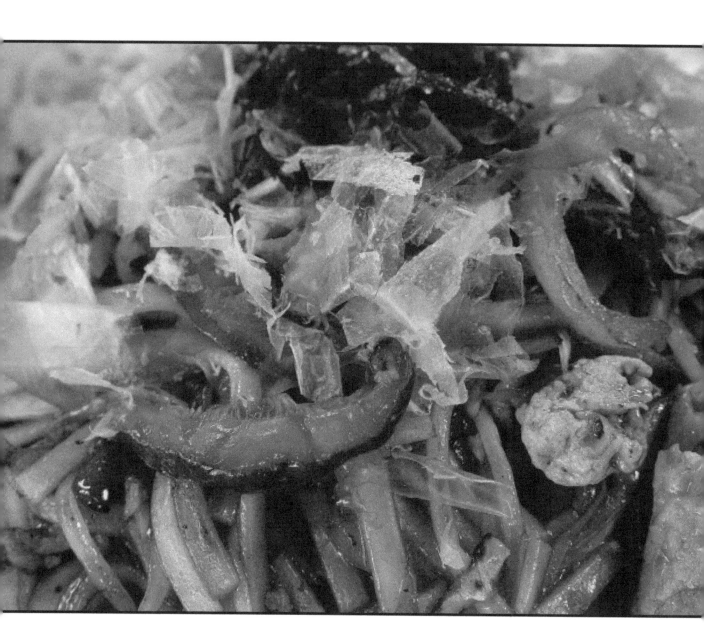

150g Tofu
40g Ginger
4 pcs Button Mushroom
1/2 Zuchini
1/2 Capsicum
1 shoot Shallots
50g Bean Sprouts
1/2 Carrots
10ml Sesame Seed
Salt & Pepper (to taste)
10ml Soy Sauce
10ml Butter
10ml Oil

Stir Fry Vegetables

Preparation:
Cut tofu in rectangular shapes of about 10cm wide. Chop button mushroom in small pieces. Slice shallots in julienne strips. Prepare flower carrots. Cut capsicum, zucchini and ginger into thin strips.

On the teppanyaki:
Heat the teppan to medium temperature. Splash a dash of vegetable oil on the hot plate. Lay tofu on to the teppan, cook for 1 minute then turn over. Set aside on the cooler part of the hot plate. Splash more oil on the heat, add button mushroom, flower carrots, zucchini and capsicum into the mix. Stir once again with spatula. Mix shallots, ginger and bean sprouts. Sprinkle salt, pepper and sesame seed. Mix again. Finally add butter and soy sauce and quickly stir before serving.

Prefer to use extra firm tofu. It holds its shape and is ideal for stir fry.

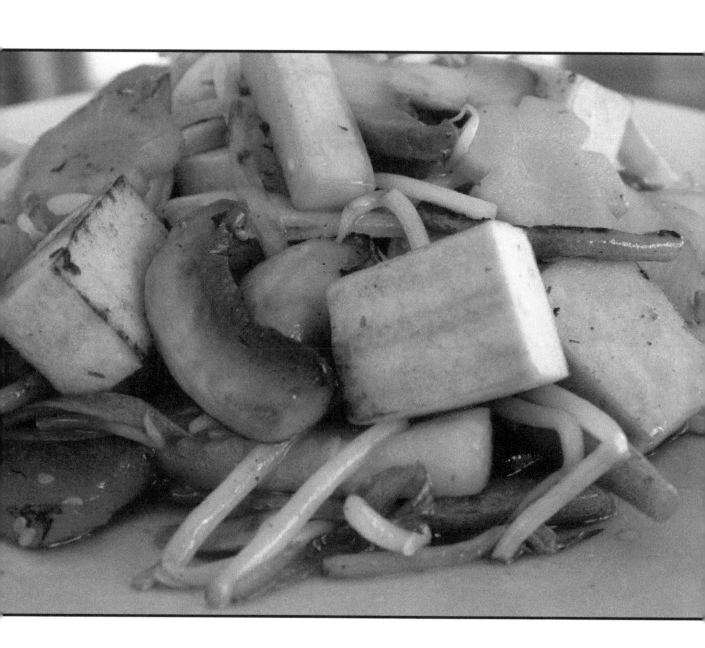

180g Rainbow Trout
4 pcs Shitake Mushroom
1/2 Bunch Bock Choy
20ml Hoisin Sauce
10ml Soy Sauce
Salt & Papper (to taste)
10ml Oil

Hoisin Trout

Preparation:

Chop boc choy stem off and wash thoroughly. Slice rainbow trout into two pieces (do not take off skin). Set aside.

On the teppanyaki

Turn both burners on to medium level, one side for the coral trout and the other one for the vegetable. Spread oil evenly with spatula. Place rainbow trout on the hot plate with its skin facing the teppan. Allow the skin to crisp before turning over (see below). Add salt & pepper on both trout and boc choy. Splash a small amount of sesame oil on the boc choy, stir and serve on the plate first. Simmer hoisin and soy sauce together on the cooler part of the teppanyaki. Scoop fish on to the sauce, making sure that the trout is covered with sauce. Scoop and place on top of the boc choy. Quickly stir-fry shitake mushroom for 2 minutes. Splash on a bit of soy sauce and place on top of trout.

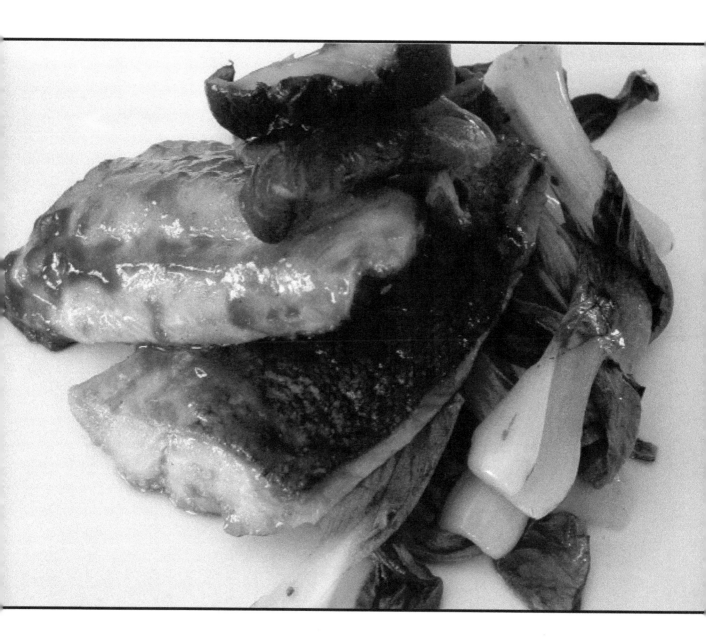

Cutting prawns on the teppan table

Sprinkle some salt on the oiled grill before laying peeled prawns with your long spatula. The salt will prevent the prawns from sticking onto the heated grill. Allow the prawn tails to dangle on the bottom edge of the spatula to make it easier to fully lay the prawns onto the grill.

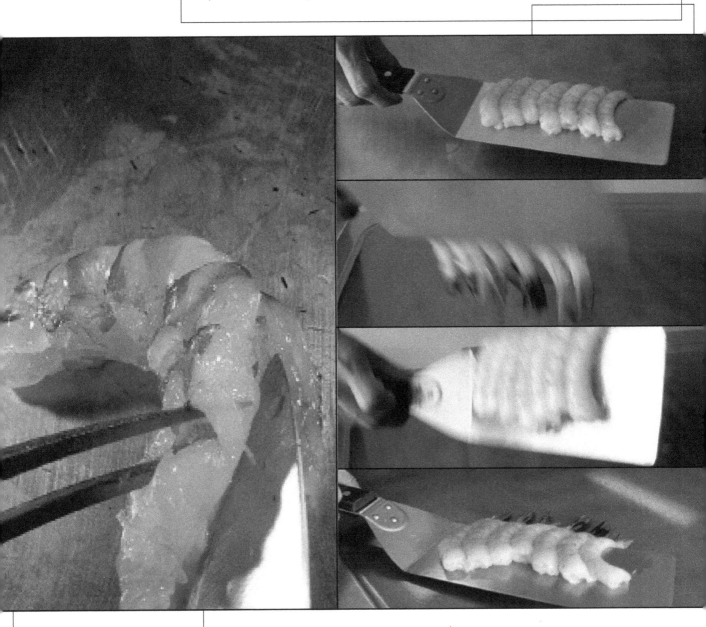

Tip:
There is more than one style of cutting prawns on the table but for the sake of bringing out the real succulence of the prawn. Score the prawn in the middle to release the tenderness of the prawn meat.

Even after peeling the shell the meat inside is naturally packed in. Without cutting the prawn in the middle. The prawn meat will tighten as it cook.

Lay prawns on salted part of teppanyaki. Sear for 1 minute before turning over. Use spatula to turn prawns upside down.

Pull one prawn towards you. Cut the tail off. Use the tip of your fork to turn the prawn from the bottom anti-clockwise.

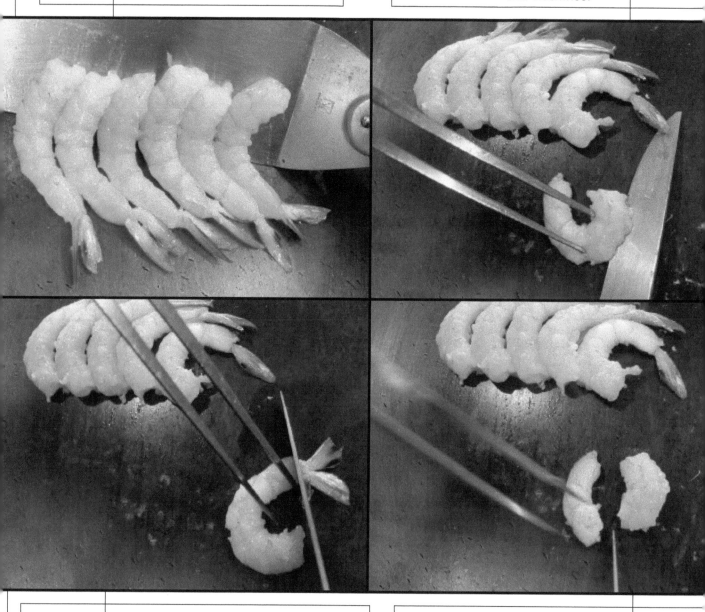

Pin the meat slightly using your fork. Score the middle of the prawn.

Cut the prawn in the middle. Repeat process with the rest of the prawn. Practice makes perfect.

200g Salmon
Salt and Pepper (to taste)
10ml Garlic Butter
10ml Oil
10ml Soy Sauce
10ml Lemon Juice

Salmon Deliquesce

On the teppanyaki:

Heat teppanyaki to high temperature. Splash a dash of oil on the teppan and spread with spatula. Lay 200g salmon on the hot plate. (See Below) Cut salmon immediately into bite size pieces. Turn over and cook other side. Sprinkle salt and pepper to taste. Set salmon to a cooler side of the teppan. Scoop a small knob of butter, let the butter melt then pour soy sauce over butter. Scrape salmon on the sauce. Thoroughly mix sauce with salmon. Serve on to a plate.

Scoop the excess sauce and pour over the salmon. Finally squeeze some lemon juice over the salmon.

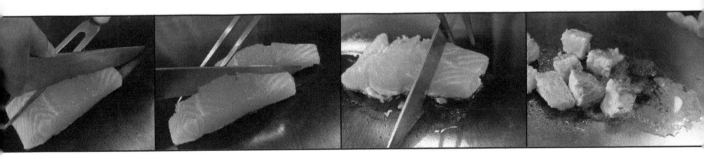

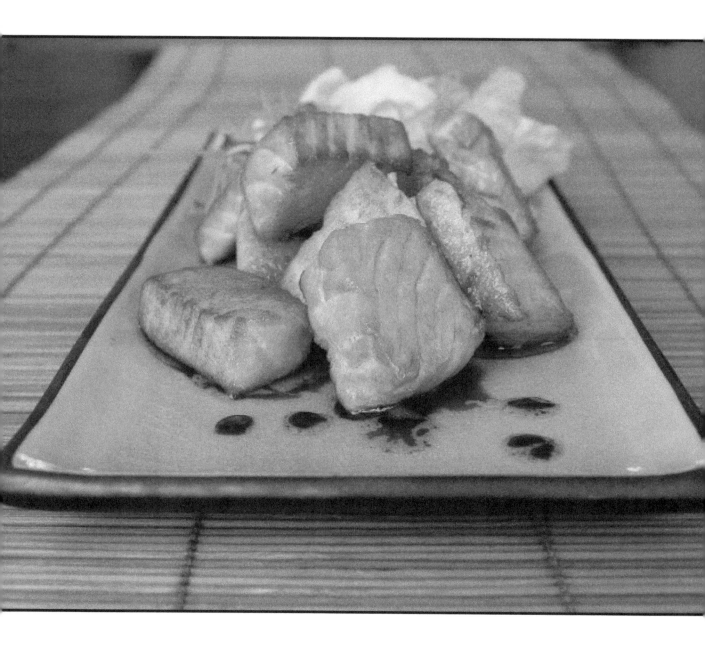

Cutting meat on the table

Lay beef on the heated part of the grill, allow the meat to instantly grip itself onto the teppan; until the surface is sealed.

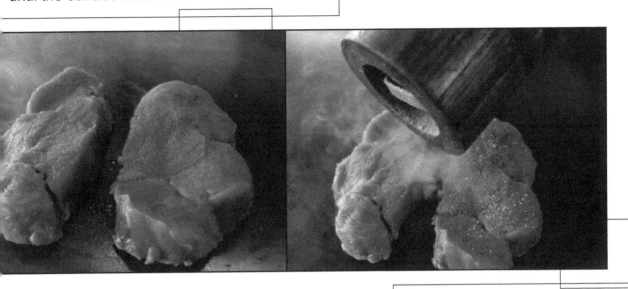

Sprinkle salt and pepper to taste

Seal one side of the beef.

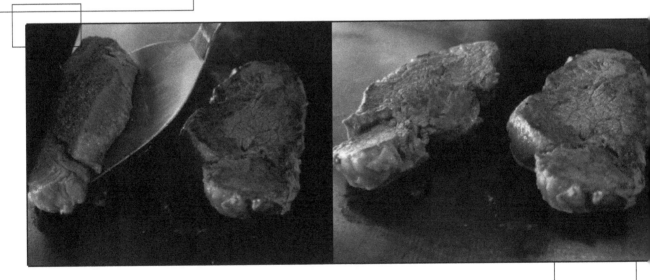

ain Fed and Grass Fed Beef:
all have personal preference as to what type of beef we want
eat. Some prioritize on health while others prefer taste. I have
und that grain fed beef contains more fat than grass fed but the fat
finitely adds to the flavour of the beef. Grass fed may be a better
oice for the health conscious but be prepared to chew the beef
ger. In the end it really is up to the individual how they want their
ce of steak.

Once sealed, turn meat over using your spatula and seal the other side.

Use your fork to guide your knife and cut the middle of the meat once.

Turn the meat to a 90 degree angle ar cut the top end.

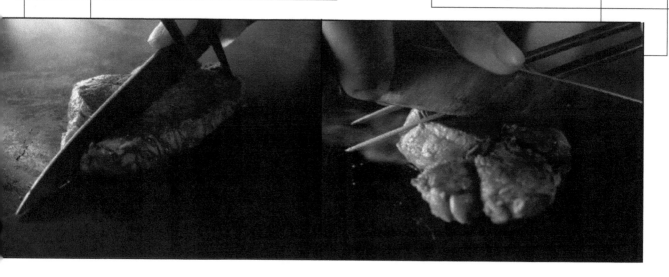

Using the same technique continue to cut the meat into cube shapes repeatedly towards the bottom

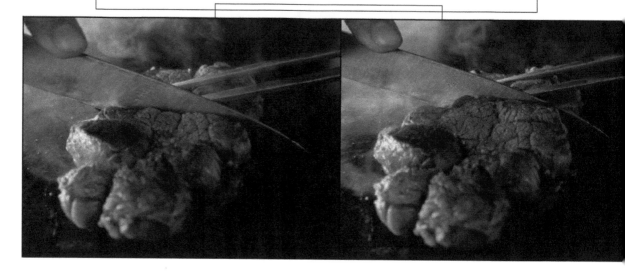

Cutting Tip:
Cutting beef on the table requires a little technique. Position the base of the knife's edge on one end of the meat; rigidly slice the meat in an arching motion pressing the knife deeper as you cut.

200g Tenderloin Beef
2 pcs Button Mushroom
10ml Garlic Butter
10ml Oil
10ml Brandy
Salt & Pepper (to taste)

Fillet Mignon

Preparation:
Cut off 180g fillet mignon steak. Chop 3 pieces of button mushroom. Prepare on a tray.

On the teppanyaki:
Set teppan to above medium heat. Splash a dash of vegetable oil and spread oil with spatula. Lay fillet mignon on hot plate. Cook both sides evenly before slicing the meat into cube size. Sprinkle salt and pepper to taste. Pour a trail of oil around the meat. Use one hand to pour brandy over the trail of oil. Quickly remove brandy bottle away from the teppan and use the other hand to light simmering alcohol (remember to never light any flamable liquids close to its container. Always keep a fair distance from the fire). Allow the fire to subside. Add garlic, butter and soy sauce. Mix thoroughly before serving.

Recommended dipping sauce:

Creamy Mustard Sauce

(Please refer to back of book)

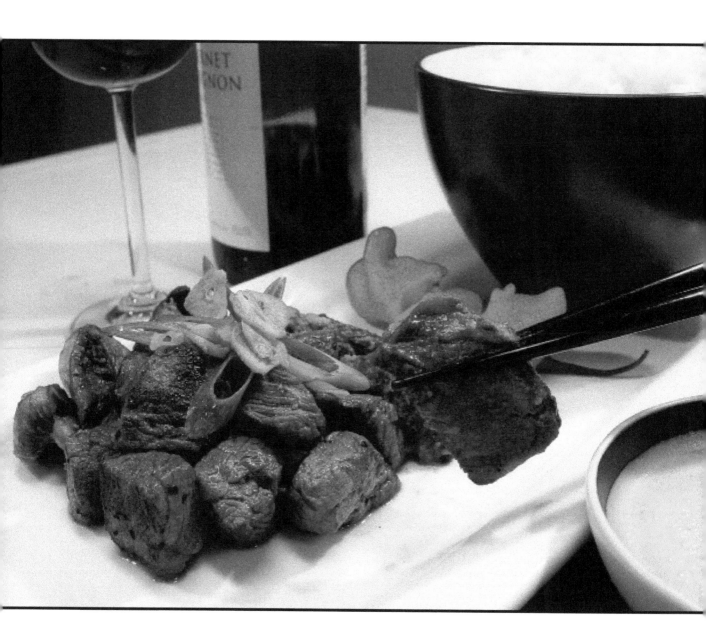

Recommended dipping sauce:

Ginger Sauce

(Please refer to back of book)

12 pcs Fresh Scallops
10ml Oil
White Pepper (to taste)
10ml Garlic Butter
10ml Soy Sauce
10ml Lemon Juice

Lemon & Scallops

On the teppanyaki:

Splash a dash of vegetable oil on the hotplate. Spread oil around the heated area. Using a spatula lay the scallops on the teppan. Seal one side for 2 minutes until the surface turns golden brown. Turn over and seal the other side (See below). Sprinkle white pepper (to taste). Quickly put scallops to a cooler side of the grill, add 1/2 tbspn of butter and soy sauce and mix. Squeeze lemon juice and mix again before serving.

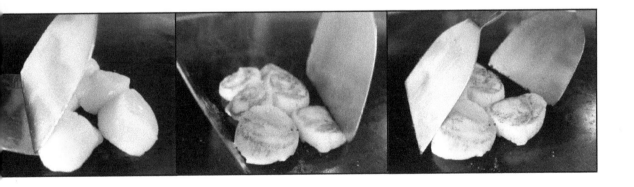

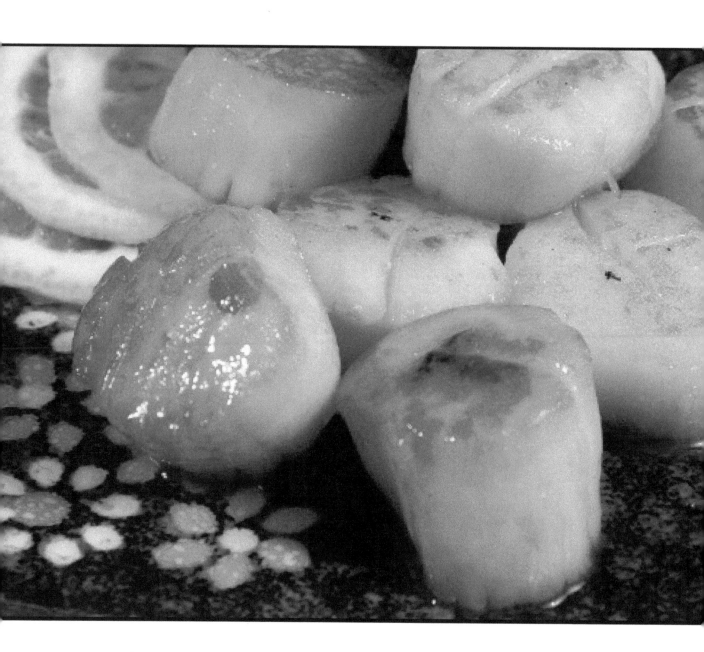

2 Sword Fish Fillet
10g Dill
10g Butter
5g Capers
10ml Soy Sauce
10ml Mirin
10ml Dijon Mustard

Swordfish with Dijon Mustard

Preparation:

Prepare a bowl of capers, partially squash capers to squeeze juice out. Finely chop dill then place in a separate bowl. Set swordfish on a serving tray. Set aside.

On the teppanyaki:

Spread oil on the heated teppanyaki using spatula. Lay swordfish on the hot plate. Cut sword-fish into cubes almost immedietely. Seal two sides of the fish. Melt 1tbspn of butter on a cooler part of the hot plate. Add 1tbspn of dijon mustard, 1/2 tbspn soy sauce and 1 tbspn mirin. Mix everything together until all ingredients have blended. Scoop dijon sauce over swordfish and mix well. Serve on a plate. Sprinkle chopped dill over swordfish. Sprinkle dill over swordfish and around serving plate.

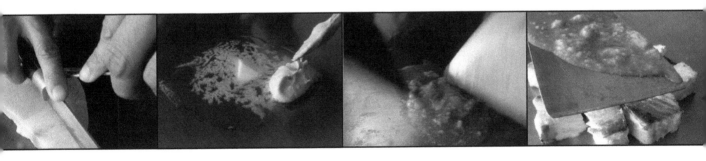

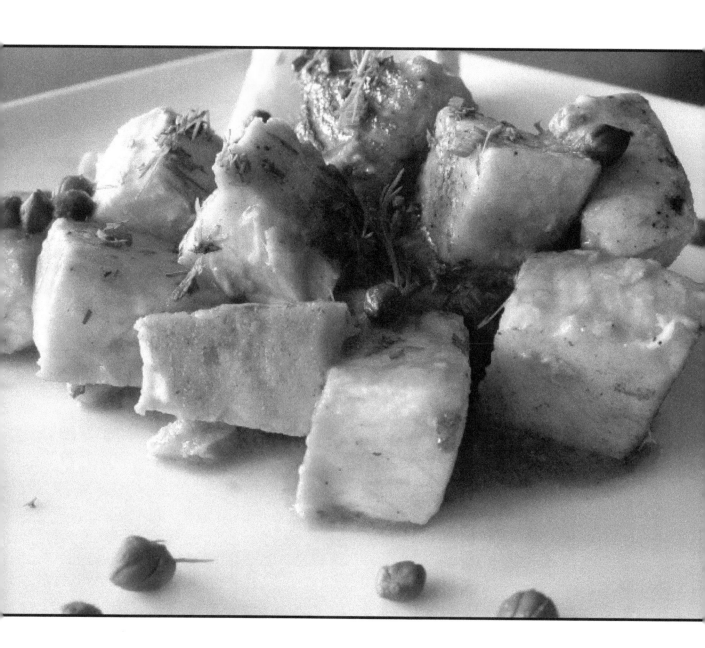

6 Thinly sliced Cube Roll
1 Shoot Shallots
1/2 Carrots
1/2 Bunch Asparagus
10ml Soy Sauce
10g Crushed Garlic
Salt & Pepper (to taste)

Beef Roll
(Usuyaki)

Preparation:
Shave cube roll into thin slices. Cut shallots and asparagus the same width as the cube roll. Grate carrots and crush garlic finely. Set vegetables aside.

On the teppanyaki:
Shallow fry crushed garlic until golden brown. Set crispy garlic on a tempura paper to drain oil. Scrape off excess oil. Saute vegetables individually on oiled hot plate. Set vegetables on a cooler part of the grill. Lay sliced cube roll on the hot plate. Quickly lay crushed garlic and your first choice of vegetables on one end of cube roll (allow a bit of space from the end of beef to set vegetables). Using your spatula carefully envelope vegetables with meat. Tuck the edge of cube rolls in and continue to roll meat. Cut beef roll in half into bite size pieces. Repeat process with the rest of cube roll slices.

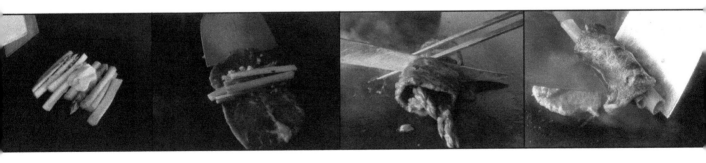

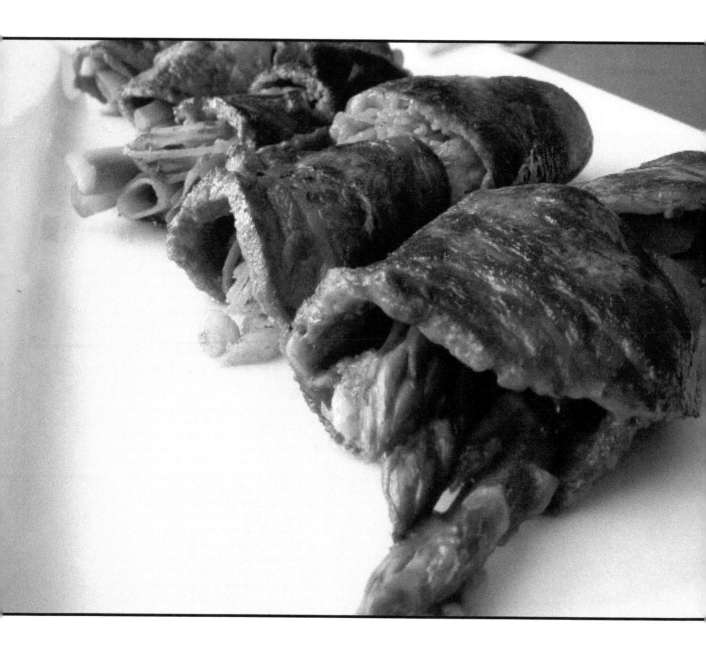

200g Chicken Thigh
1 shoot Schallots
3pcs Mushroom

Teriyaki Sauce:
250ml Mirin
120ml Sake
250ml Soy Sauce
370ml Sugar
10ml Pineapple Juice
10ml Cornstarch

Teriyaki Chicken

Making teriyaki sauce:

Mix mirin and sake into a deep pan and bring to boil. Keep a fair distance and light mirin and sake to burn off alcohol. Add sugar and stir until dissolved. Pour soy sauce, tomato sauce and pineapple and allow to simmer. Add finely chopped ginger and 2 tspn black pepper. Dissolve cornstarch with water then pour with teriyaki sauce. Stir until sauce has thickened. Turn fire off and allow to cool.

On the teppanyaki:

Spread oil over hot plate. Lay Chicken thigh with spatula. Cook one side of thigh brown and crispy for 1 1/2 minutes. Turn over and allow other side to cook. Cut chicken thigh in half before rotating diagonally to cut into bite size pieces. Saute mushroom and mix with chicken. Chuck a small knob of butter on the cooler part of the teppan. Let teriyaki sauce simmer. Mix chicken thigh with sauce making sure that the meat is covered with sauce. Sprinkle sesame seed and quickly mix again before serving.

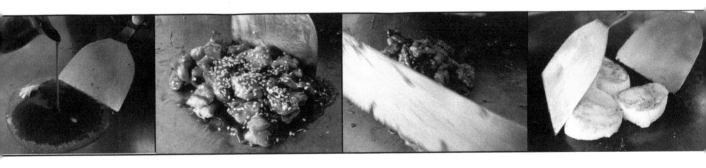

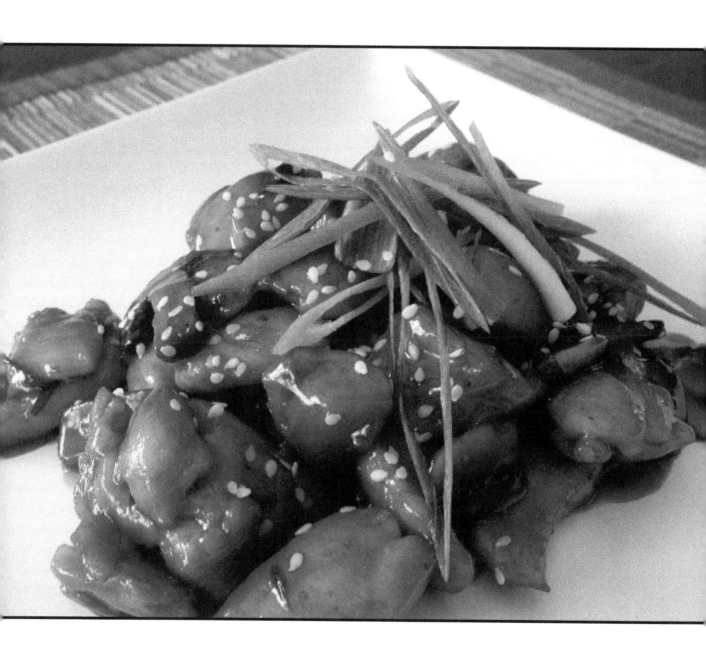

400g Pork Fillet
1 Onion
8 Leaves Chinese Cabbage
20ml Kimuchi paste
Salt & Pepper (to taste)
10ml Sesame Oil

Pork Kimchi

Preperation:

Thinly slice 400g pork fillet and 1 onion. Cut 8 leaves Chinese cabbage. Mix all three ingredients together in a large bowl. Sprinkle salt and pepper (to taste). Stir in 5 tspn of kimuchi. Marinate pork kimuchi for 10 minutes.

On the teppanyaki:

Spread sesame oil over the hot plate. Simmer pork kimuchi and allow to caramelize. Mix with spatula cooking all sides. Splash a little bit more sesame oil for fragrance. Scoop and serve.

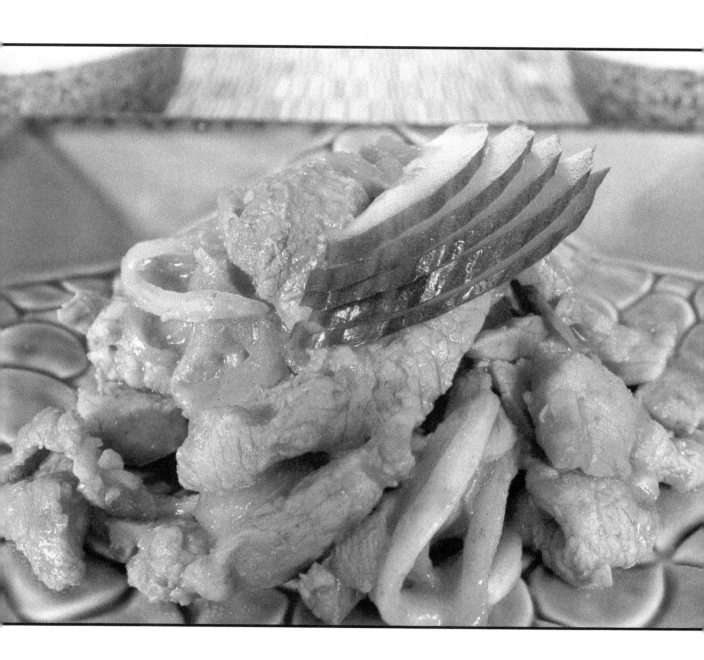

200g Snapper Fillet
20g Corriander
30ml Milk
90 ml White Wine
20g Butter
1 Shoot of Schallot
Salt and Pepper (to taste)

Snapper Papillote

Preparation:

Fold 30cm of aluminum foil into a rectangular shape once. Place 20g of butter on the middle of the foil. Lay the snapper on top of butter. Add cracked pepper and 90ml of white wine and milk over the fish. The snapper will soak some of the liquid but maintain the liquid in the centre of the foil. Place sliced shallots on top of the fish. Join the two sides of the foil together length wise and fold. Close the shorter ends of the foil by tucking it 10cm inward.

On the teppanyaki:

Lay the papillote on heated teppan. Allow the papillote to simmer inside. After a couple of minutes you will see that aluminium foil will start to balloon out. This indicates that the snapper is ready to serve. Use the spatula to pick up onto a serving plate. Allow to cool before opening.

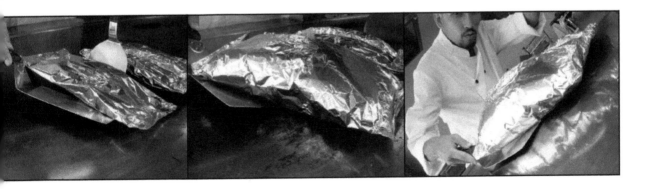

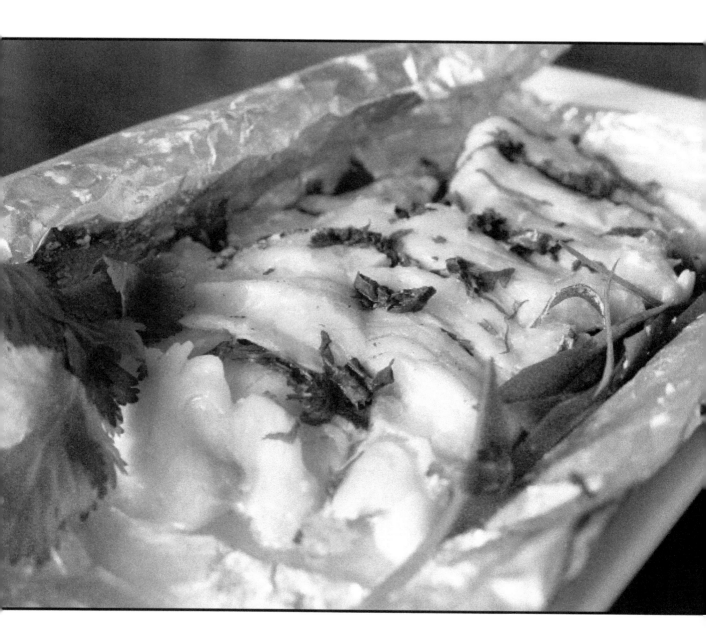

200g Duck Fillet
10g Pecan Nut
120ml Maple Syrup
10ml Dijon Mustard
Salt & Pepper (to taste)

Pecan Duck Fillet

Preparation:

Crush pecan nuts and set aside in a bowl. In a container stir maple syrup and Dijon mustard well until both have blended thoroughly. Set aside.

On the teppanyaki:

Splash a dash of oil on the hot plate. Cook duck on one side for 2 minutes before turning over. Scrape excess oil off the teppan repeatedly. Slice duck fillet julienne style. Sprinkle salt and pepper to taste. Scoop duck meat with both spatula; softly squeeze off excess oil before serving on a bed of mixed lettuce. Pour maple mustard sauce over the meat. Sprinkle crushed pecan around the meat and plate. Serve.

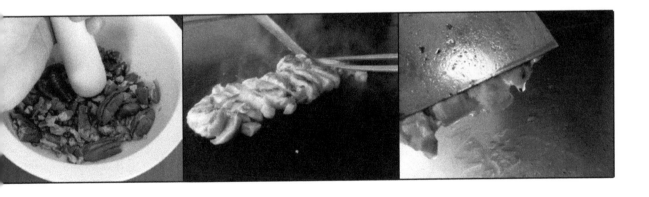

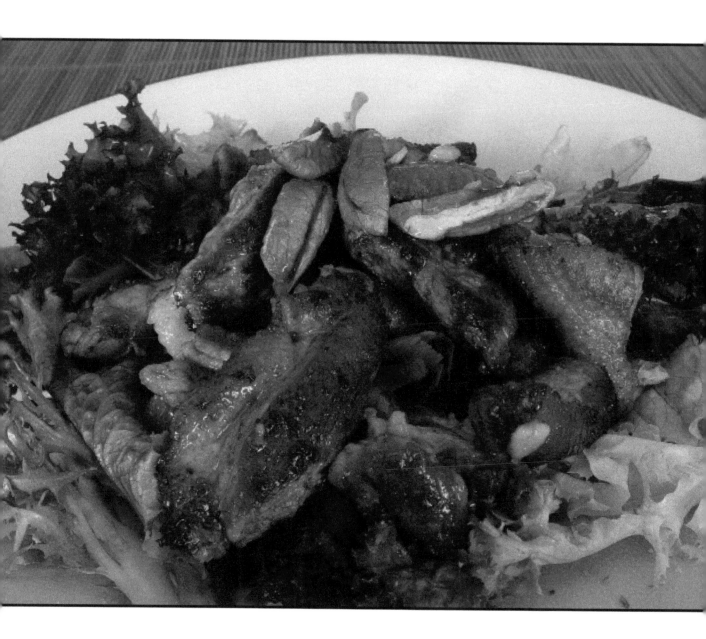

1 Pork Loin Fillet
3 Apples
30ml Water
30g Sugar
5g Nutmeg
5g All Spice
5g Cinnamon
10ml Butter
Salt & Pepper (to taste)

Pulped Apples over Tenderloin Pork

Preparation:

Mix apple & water in a pan. Cover the pan to simmer, stirring occasionally for about 10 minutes until chopped apples have softened. Pulp half the amount of the fruit with spoon. This will give the apple sauce that rustic texture. Stir in sugar, all spice, nutmeg, cinnamon and butter. Stir.

On the teppanyaki:

Heat the grill and splash a dash of oil. Lay the whole tenderloin onto the preheated teppan plate. (1) Sprinkle salt & pepper over the meat. (2&3) Cut tenderloin from one end 10cm thick towards the bottom. (4) Lay one side of pork fillet flat to seal. Turn fillet over with spatula and seal other side. Chuck butter on the fillet and mix thouroughly. Scoop and serve on a plate. Simmer apple sauce on a cooler part of teppan. Scoop sauce and pour over the tenderloin pork.

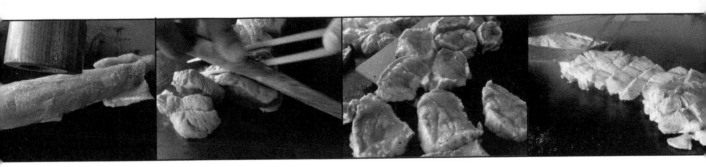

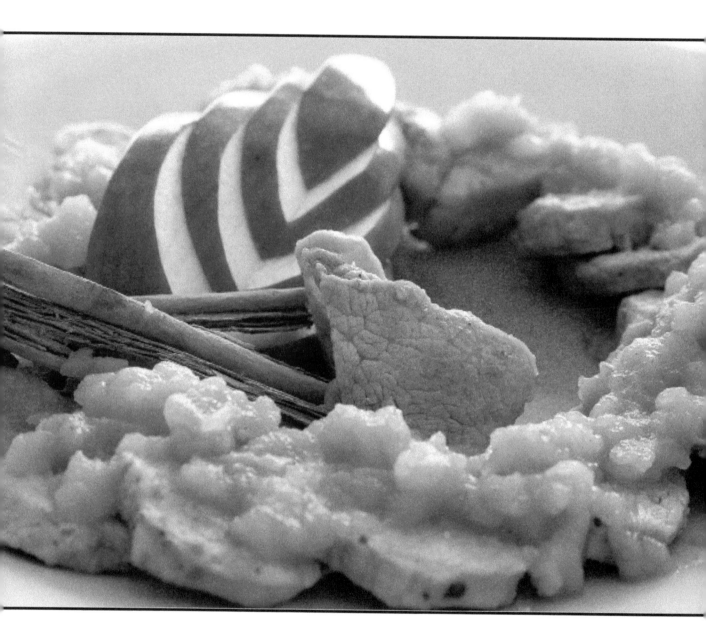

2 Fillets Mackerel
100g Spanish Onions
10g Parsley
250ml Coconut Milk
10ml Butter
5ml Fish Sauce
5g Crushed Garlic
5ml Corn Flour
Salt and Pepper (to taste)

Mackerel on Coconut Sauce

Preparation:

Finely chop parsley and spanish onion and set in separate bowls. Use crushed garlic for this recipe. Mix corn flour with tepid water to dissolve powder.

On the teppanyaki:

Chuck a knob of butter on the hot plate. Saute onion and garlic until the onion caramelize. Pour coconut milk on the outer rim of the heat and simmer. Mix spanish onion and garlic with coconut milk. Add the chopped parsley and fish sauce and stir. Scoop coconut sauce on a serving plate. Scrape and wipe the hot plate clean. Splash a dash of oil on the teppan. Lay the sliced mackerel on the teppan. Allow the fish to stick to the hot plate until the surface crisps. The fish will then naturally separate from the hot plate. Cook both sides evenly. Add salt and cracked pepper. Scoop mackerel off the hot plate and lay fish on the bed of coconut sauce.

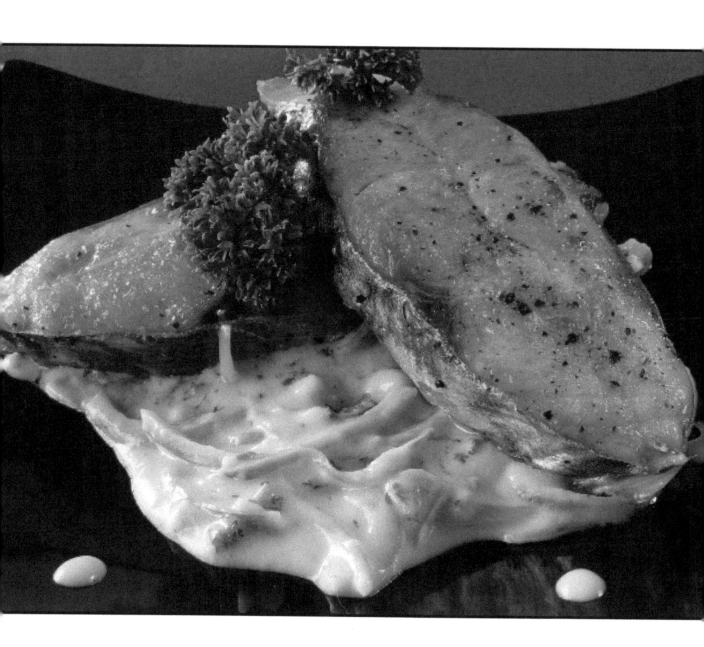

4 King Prawns
6 Egg Yolks
10ml Butter (unsalted)
30ml White Wine
10ml Lemon Juice
10g Cayenne
Salt (to taste)
1 Bunch Asparagus

Prawn Hollandaise

Making the Hollandaise Sauce:

Add egg yolks to a sauce pan and whisk until it starts to thicken. Slowly melt 1/3 amount of the butter in a low heat and whisk constantly. Add more butter and repeat the process over the low heat until you have used up all the butter. Season with cayenne pepper and Salt. Pour lemon juice and white wine and whisk again. Set in a bowl.
Chop bottom end of asparagus and peel skin off.

On the teppanyaki:

Saute asparagus on oiled teppan plate. Cook for 1 minute. Sprinkle sea salt. Add butter and roll asparagus around. Serve on a plate first.
Splash some oil on the hot plate and lay the sliced prawn on the teppan with your spatula. Turn prawns over with spatula. Pour the heated Hollandaise sauce over the prawns. Cover prawns with a teppanyaki lid. Steam for 1 minute. Take lid off, scrape off and serve last.

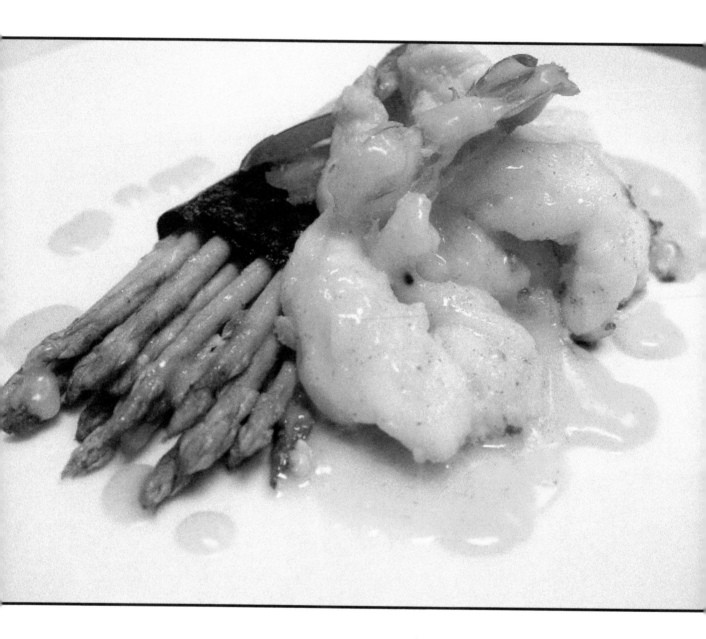

100 ml Thicken Cream
90 ml Boursin Cheese
4pcs Sundried Tomato
300g Scallops
40g Shalllots
1/2 pc Lime
10ml Olive Oil
Cracked Pepper (to taste)

Boursin Cheese Scallops

Preparation:
Finely chop shallots. Chop sun dried tomato julienne style. Place each ingredient in separate bowls.

On the teppanyaki:
Splash a dash of olive oil on the teppan, spread oil with spatula. Saute shallots and sundried tomato for 30 seconds. Set aside on a cooler part of the hot plate. Pour 100ml of thickened cream over sauted vegetables. Mix boursin cheese with cream and allow the cheese to melt. Once thickened scoop sauce and serve on a serving plate. Scrape sauce off the teppan. Scrape and wipe teppan clean.
Pour another dash of olive oil onto the hot plate. Place scallops on the teppanyaki. Saute both sides. Sprinkle cracked pepper over scallops. Cover scallops with butter before serving on a bed of boursin cheese sauce.

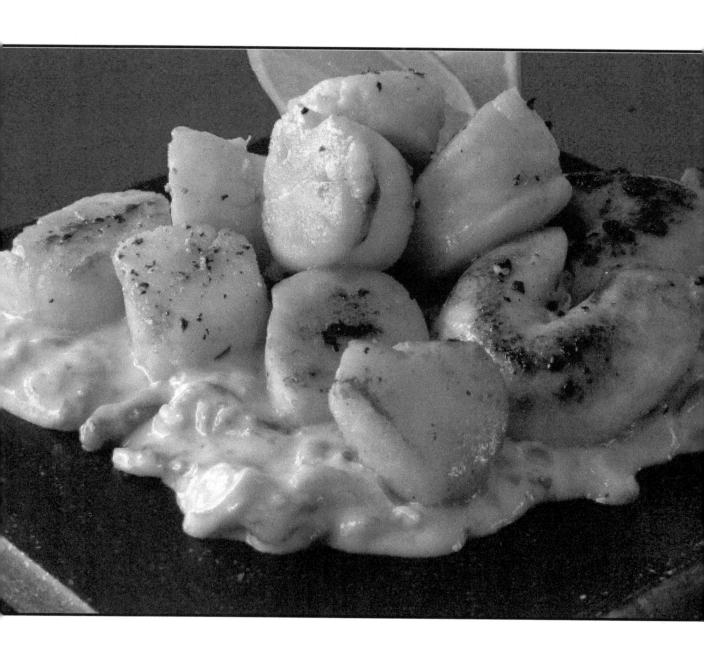

Cutting Prawns on the Table

nsert the edge of the knife from the top body just below the prawn head)

Slice from the top to the bottom. Allowing the shell to open up.

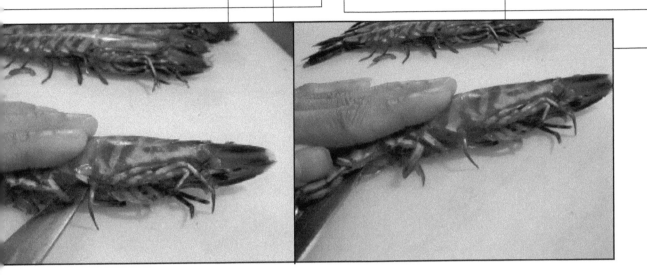

Prick the middle part of the prawn, holding it down. Use the edge of your knife again to pin the prawn head.

Separate the head shell away using your knife

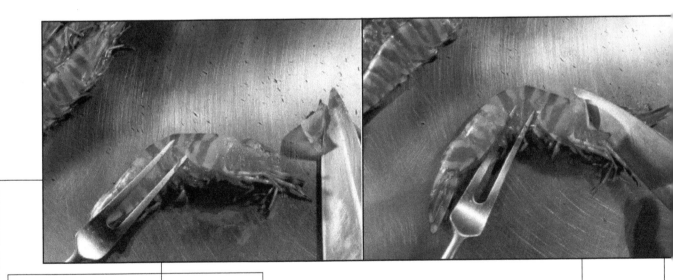

Now insert knife in between the meat and legs to separate.

Loosen the shell using your knife to peel the front part of the shell. Make sure that your fork has not pierced the shell.

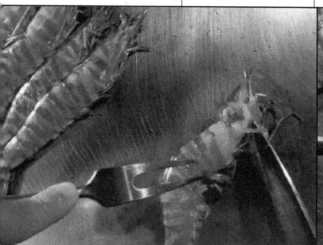

Pin the shell with your knife on the grill. Using your fork to lift the meat up and separate it from the shell.

Again prick the middle part of the prawn with your fork. Slice above the body of the prawn.

8 pcs Prawn Legs
8pcs Prawn Tails
10ml Soy Sauce
10ml Butter
10ml Lemon Juice
Salt (to taste)

Crispy Prawn Tails

Preparation:

Separate prawn tails and legs from the meat.

On the teppanyaki:

Splash a good amount of oil on the teppan. Set prawn legs and tail on the hot plate. Flatten legs with spatula along with tails. Add more oil and shallow fry for 3 minutes. Turn over and fry again for 1 minute. Chuck a small amount of butter on the cooler side of the hot plate, allow to melt then add soy sauce. Mix prawn legs and tails with sauce. Squeeze lemon and quickly serve.

Keeping the teppan table clean while you are cooking and when you finish is a vital part of any cooking process. As you have noticed there are a few dishes that require sauces to be heated and mixed with the meat on the hotplate. While certain dishes are meant to be cooked this way, in effect, it makes the teppan plate messy.

There are a number of ways to minimize your hot plate from getting dirty. Always wipe your table clean before you start cooking, because you are cooking in front of your guests, you want to give them the comfort that the table is hygienic and clean of any grime left from the last dish. Once cooking has started food deposits will stick on the teppan. Scraping the food residue with your spatula or a scraper is always a good idea straight after you have served the food (illustrated above). Allowing the residue to remain while the teppan is still hot will only make the hotplate harder to clean later (this applies especially with sauces). Using a clean wet cloth, wipe down the table occasionally.

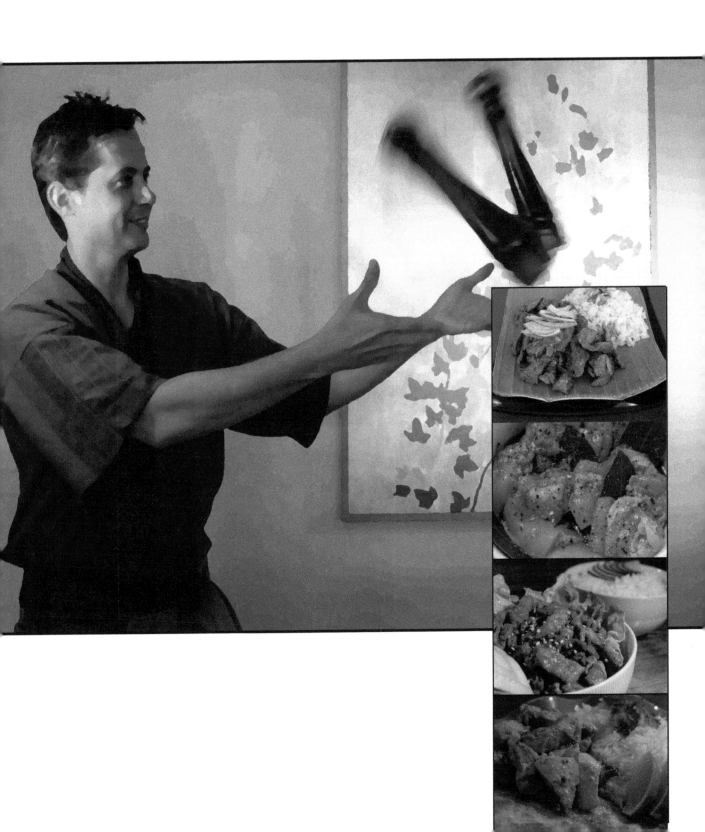

Marinades are commonly used to add a unique flavour to its meat as well as to tenderize the flesh of the meat. Most marinade recipes contain acidic ingredients to breakdown the protein fibre and soften the meat. Ingredients such as vinegar, oil, wine and citrus are used regularly. When marinating, make sure to cover the entire meat with the sauce to let it soak properly. If the marinade sauce is not enough, turn it over regularly for an even balance. Keep all marinades refrigerated especially if you are soaking for more than half an hour. Different meats require different amounts of time to soak. Poultry and beef, for example, will take longer than fish. A combination of ingredients can be used to boost the flavours of a dish even giving it a signature taste or simply a subtle background flavour. Ginger, for instance, gives a pungent flavour when mixed. Sweeteners like sugar or honey help balance the overall flavour as well as minimizing the sharpness of other ingredients such as citrus based recipes.

Marinade

200g Sirloin Beef
10ml Soy Sauce
10g Ginger (grated)
30ml Dry Cherry
10g Garlic Clove
1/2 Onion
10g Chilli
10ml Sesame Oil
Sesame Seed (to taste)
10g Sugar

Beef Bulgogi

Preparation:

Thinly slice beef and onions. Mix with grated ginger, crushed garlic, red pepper flakes, sugar, soy sauce, dry cherry and sesame oil. Marinate in a bowl for about half an hour before cooking.

On the teppanyaki:

Heat teppanyaki to medium level temperature. Splash a drop of peanut oil. Place marinated beef on the hot plate. Cook bulgogi evenly by separating the meat using spatula. Add sesame oil just before serving, constantly mix with your spatula until beef bulgogi is medium rare. Sprinkle with sesame seed on top.

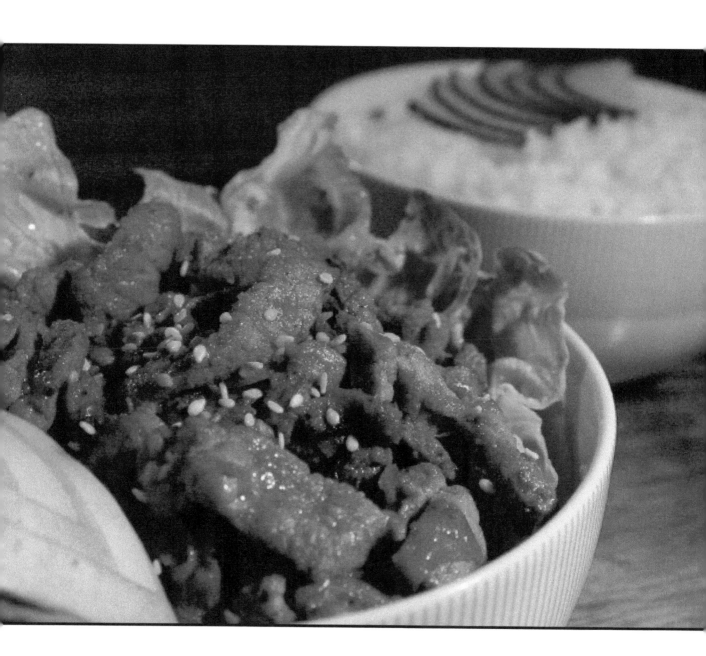

500g Sirloin Beef
2 clove Garlic (crushed)
10g Pepper
250ml Soy Sauce
10ml Lemon Juice
10g Sugar
1 Small Onion

Tagalog Steak

Preparation:

Thinly slice sirloin steak and Spanish onions. Place steak and onion in a bowl. Slice garlic and evenly distribute over steak. Add cracked pepper, soy sauce sugar and lemon juice. Marinate for 30 minutes.

On the teppanyaki:

Pre-heat teppanyaki. Splash a dash of oil and spread on the hot plate. Set Tagalog steak on the teppan. Constantly stir Tagalog marinade with spatula. Regularly pour remaining sauce from the bowl as the sauce dries up. Scoop from the hot plate and serve.

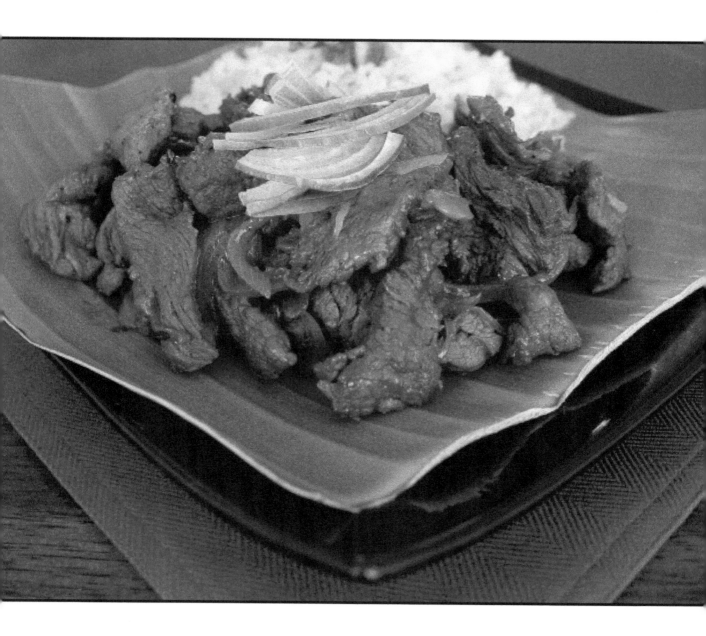

200g Chicken Thigh
3 pcs Fresh Bay Leaf
30g Sugar
30ml Balsamic Vinegar
70ml Soy Sauce
10g Cracked Peppercorn

Adobo Marinade

Preparation:

Mix soy sauce and balsamic vinegar in a bowl. Add sugar and cracked pepper. Butterfly chicken thigh in the middle and tuck fresh bay leaf in between. Soak chicken with marinade ingredients in a container for 30 minutes. Add cracked pepper.

On the teppanyaki:

Heat up hot plate to a moderate temperature. Splash a dash of oil. Lay chicken thigh on hot plate and cook both sides on moderate temperature. Baste chicken adobo regularly with remaining marinade. Scoop and serve.

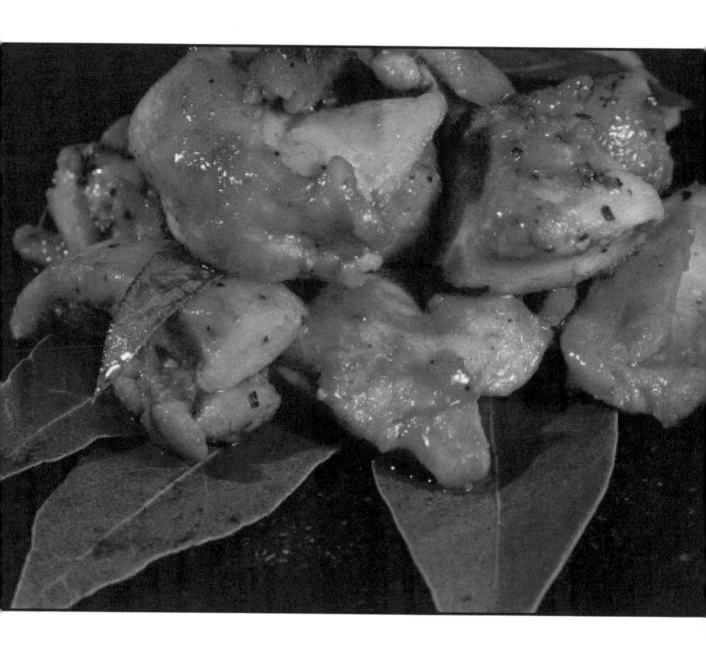

400g Chicken Thigh
150ml Greek Yoghurt
30ml Tandoori Paste
10ml Lime Juice
30g Coriander Leaves
10g Ginger (grated)
10g Lemon Grass
Salt (to taste)
10g Cayenne

Tandoori Chicken

Preparation:

Mix yoghurt, tandoori paste, limejuice, coriander leaves, garam masala and garlic in a bowl. Place chicken thigh in bowl and mix well. Marinate in the fridge for an hour.

On the teppanyaki:

Pre-heat the teppan to a moderate temperature. Spread peanut oil over hot plate. Using a tong, pick chicken pieces and set them on the teppan shaking off excess sauce. Allow to cook for 2 minutes before turning over to cook other side of chicken evenly. Once the chicken has cooked, baste remaining sauce with the marinade from the bowl. Scoop onto a bed of naan bread.

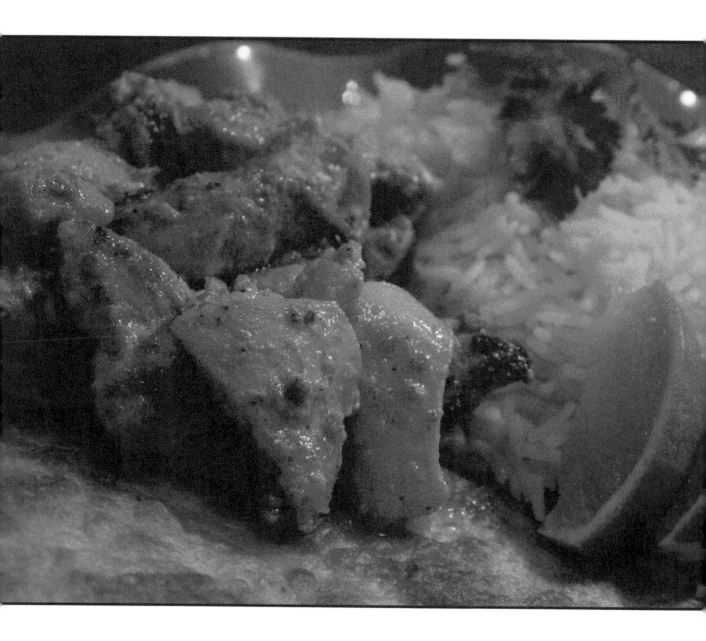

Recommended dipping sauce:

Creamy Chilli Sauce

(Please refer to back of book)

200 g Baby Octopus
2 tspn Fresh Chilli
1 tspn Crushed Garlic
1 tspn Balsamic Vinegar
1 tspn Soy Sauce
3 tspn Red Wine
1 tspn Worsteshire Sauce

Baby Octopus Marinade

Preparation:

Finely chop fresh chilli and place in a bowl. Pour chilli with balsamic vinegar, red wine, soy sauce and Worstershire sauce into a container. Mix baby octopus with marinade and refrigerate for an hour.

On the teppanyaki:

Place octopus on hot plate turning over regularly. Brush more of marinade over the octopus to keep octopus moist. Cook octopus quickly on all side evenly and lightly to prevent meat from becoming too rubbery.

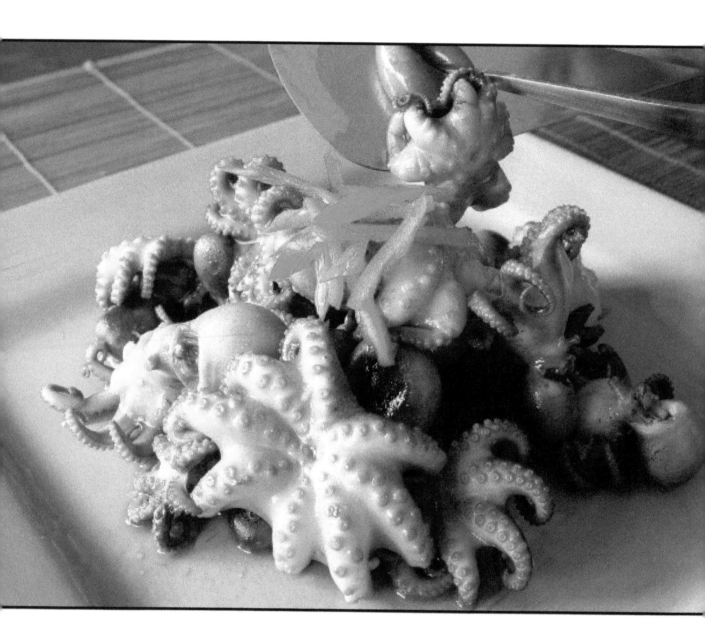

1/2 kg Beef Ribs
1 tspn Sesame Seeds
1 cup Soy Sauce
3 tspn Sugar
4 tspn Sesame Oil
8 tspn Green Onion
(finely chopped)
6 clvs Garlic (chopped)
1 Pear (grated)
Salt (to taste)

Beef Bulgogi

Marinade:

Place one beef rib on the chopping board. With the bone on the chopping board and the meat facing upward, score the meat 2mm thick right to one end. Open sliced section of the galbi. Turn beef rib 180 degrees and score meat again directly under the open section. Repeat this process until you have scored close to the bone, shaping the galbi into a long thin slice. Place the beef rib in a large bowl. Mix soy sauce, pear juice, sugar and sesame salt. Stir once. Add chopped green onion, minced garlic and sesame oil and stir again. Refrigerate beef galbi for 1 hour before cooking.

On the teppanyaki:

Pour oil on a heated plate and spread across the table. Use a tong to set galbi on the hot plate. Seal one side before turning over to seal the other. Cut galbi into bite size pieces and mix quickly. Baste galbi with remaining sauce and thoroughly mix again before serving.

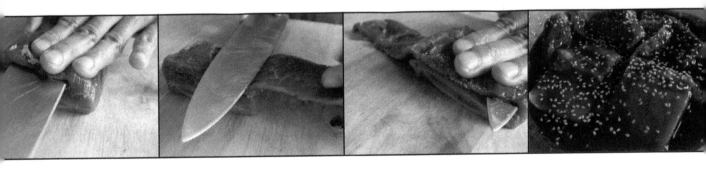

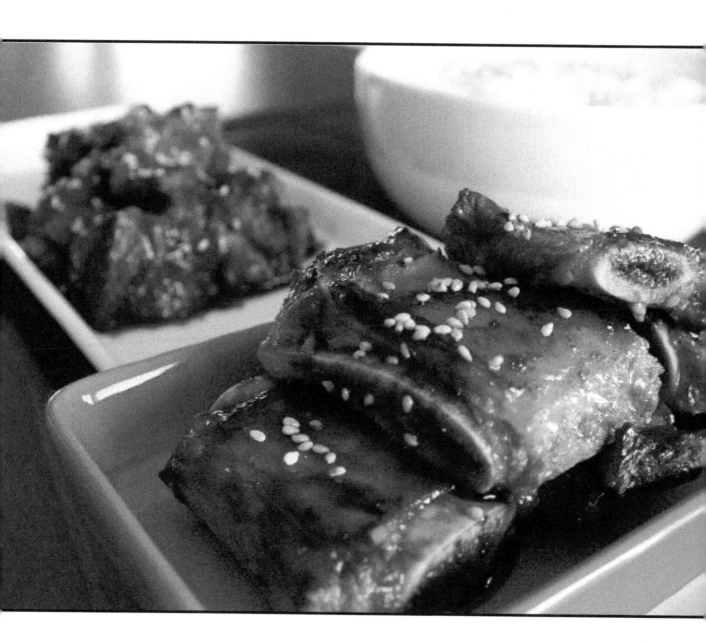

Creating a Volcano Tower Stack

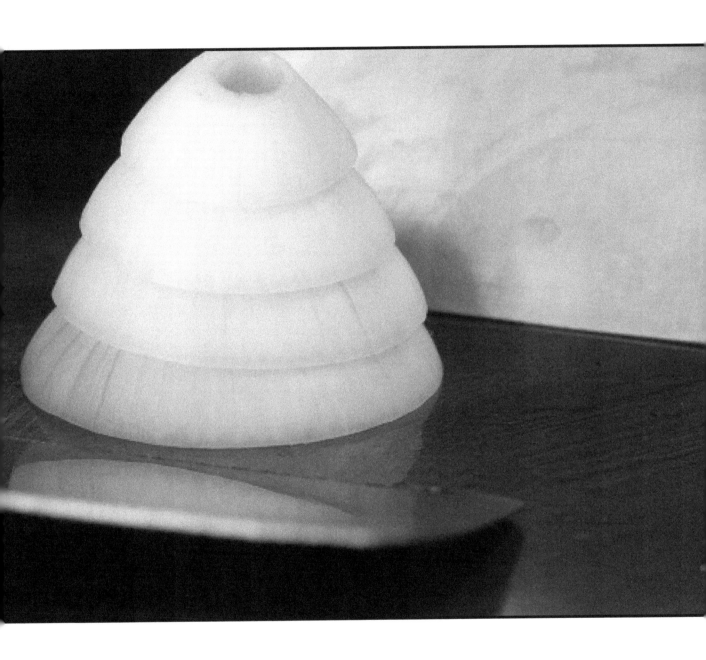

Take the outer layer and place it on one side of the grill.

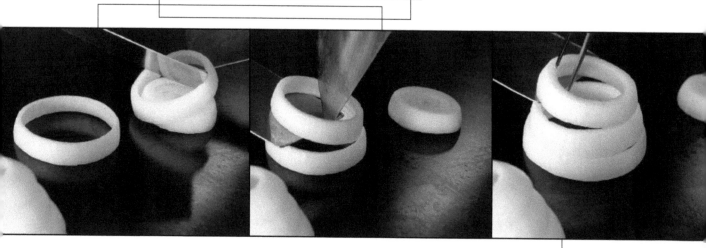

Pick up another layer and carefully place on top of the first layer. Repeat the process continuously.

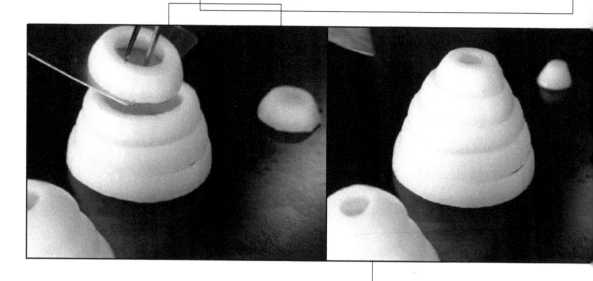

Leave the last piece of onion out. You need a hole on top for the fire to burst out

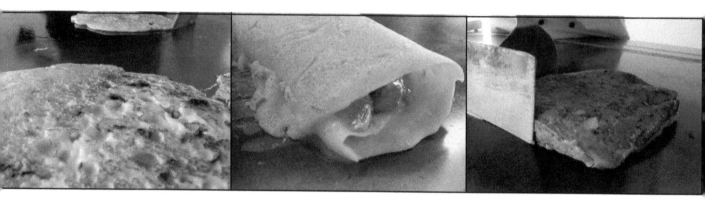

A Teppanyaki table is a perfect set up to follow flour based recipes. An ideal cooking apparatus that can beusedfor breakfast,lunch and dessert. Flour and eggs based recipes are very easy to follow and much easier to cook on a flat grill providing that you cook these recipes at relatively low heat. Flour burns easily and changes properties at slight variations of heat. Mixing eggs together with flour and cooking it at a proper level temperature allows the egg mixture to bind other ingredients together nicely. Suitable heat should be applied to each recipe.

Flour & Eggs

1 Egg
3 cups Milk
10 ml Vanilla Essence
2 tspn Sugar
1/2 tspn Salt
400 g Flour
1 tspn Melted Butter
80ml Strawberry Creme

Strawberry Crepe

Preparation:

Pour 400g of flour in a bowl. Add eggs and milk in a bowl. Beat ingredients until roughly blended. Add melted butter in as well as salt, sugar and vanilla essence. Beat until sugar and salt have dissolved. Sprinkle 400g of flour slowly while constantly beating.

On the teppanyaki:

Pre-heat teppan to a low temperature. Saute strawberries until soft and set aside. Chuck a knob of butter on the hot plate and spread with spatula. Pour desired amount of crepe batter. Spread batter lightly with spatula. Pour strawberry creme over batter and spread lightly to mix. Scoop strawberries and place evenly over crepe. Scrape one end of the crepe to loosen the bottom. Using a spatula, carefully roll the crepe inward. Tuck the edge of the crepe as you roll.

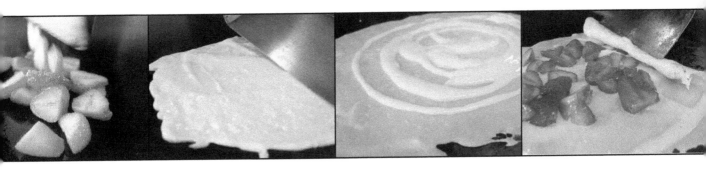

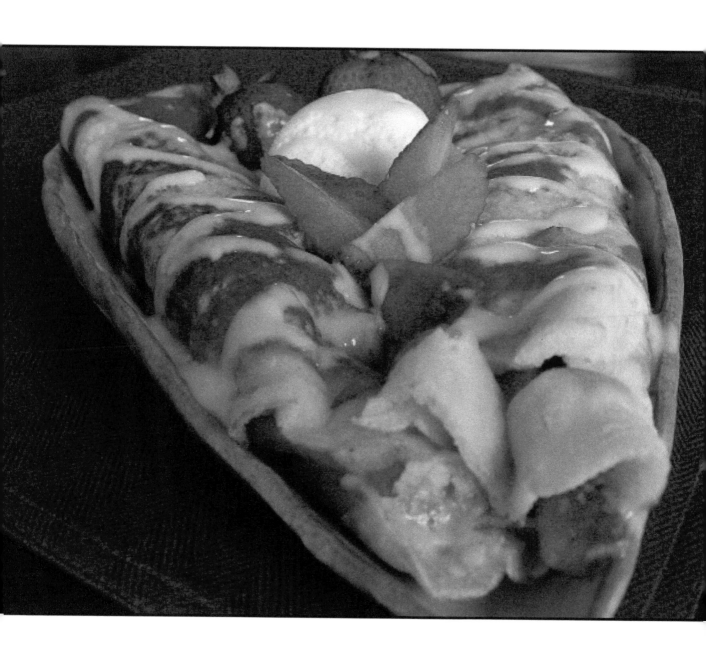

150g Pork Fillett (thinly sliced)
300 g Flour
1 cup Water
2 eggs
1/2 Cabbage
1 Yamaimo (Mountain Potato)
1 tspn Shaved Bonito
1 tspn Grated Nori
Salt (to taste)

Topping:
Brown Okonomiyaki sauce
Japanese Mayonnaise

Okonomiyaki

Preparation:
Peel yamaimo's skin and boil to soften (if you can't obtain yamaimo, use sweet potato instead). Allow to cool and rustically mash yamaimo. Set aside. Finely slice cabbage into strips. Fine slice mushroom, chicken breast and pork fillet. In a large bowl, mix the ingredients together with 300g of flour, 2 eggs and 1 cup water. Mix well. Add all prepared ingredients with okonomiyaki batter. Sprinkle salt and pepper. Set aside.

On the teppanyaki:
Preheat teppanyaki to low level temperature. Spread oil over hotplate with spatula. Pour okonomiyaki batter evenly. Using your spatula, form okonomiyaki into square shape. Cook the bottom slowly to allow the heat to reach the middle. Once the bottom is brown, turn over with spatula. Cook other side. Cut okomiyaki into four pieces again using your spatula. Serve on a plate. Squeeze Japanese style mayonnaise and brown okonomiyaki sauce on top. Sprinkle aonori and katsuobushi (dried bonito) on top. Serve.

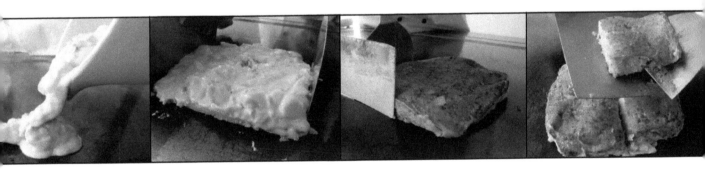

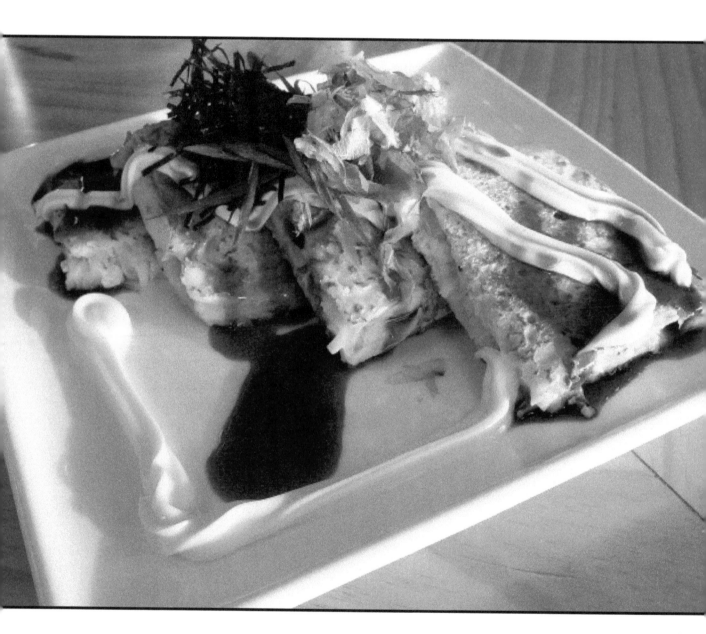

2 Eggs
2 cups Milk
2 tspn Butter
1/4 tspn Vanilla Essence
1/2 tspn Baking Soda
2 1/2 cup Flour
1/2 Punnet Blueberries

Pancakes

Preparation:

Add eggs and milk in a bowl and give it a quick stir. Slowly sprinkle flour in with eggs and milk while constantly stirring. Add in vanilla essence. Using your fingers, pinch blueberries to squeeze out the juice onto the batter. Add remaining blueberries in the batter and stir.

On the teppanyaki:

Heat teppanyaki plate to a low level of heat. Spread melted butter over the heated part of teppan. Pour pancake batter over melted batter. Spread batter to form a traditional round shaped pancake. Flip over once one side has turned golden brown.

Dipping Sauces

An additional part of teppanyaki is making complimentary dipping sauces for your chosen meal. Most dishes cooked on the teppanyaki are simmered with sauces and marinades. Meats and vegetables cooked on the teppan traditionally require a complimentary dipping sauce to enhance the flavour of your meal if you so choose. The following recipes used to make these sauces are of oriental origin. However some European ingredients can be noticed. If it works well, then use it. This eclectic but simple approach is the best key for a good teppanyaki.

Mustard Sauce

150g Yellow Mustard Powder
500ml Iced Water
100g Sesame paste
750ml Soy Sauce
100ml Thickened Cream

Stir 50g mustard powder with hot water in a bowl. Scrape mustard paste into a blender. Add 500ml cool water, 100ml sesame paste and 1ltr soy sauce. Blend.

Whip 100ml thickened cream until semi-solid. Mix with mustard sauce and whisk to blend together.

Thinly slice 30g chilli and equivalent of 1 tspn of shallots. Grate 1 tspn ginger. Mix all three ingredients with 50ml of light soy sauce. Stir.

30g Chilli Powder
1tpsn Shallots
50ml Light Soy Sauce
1tspn Grated Ginger

Chili Sauce

Sesame Sauce

50g Sesame Paste
50g Peanut Butter
100ml Soy Sauce
1/2tspn Sugar
100ml Sake
100ml Mirin
1tspn Sesame Oil
1/2 tspn Vinegar

Boil 100ml sake and 100ml mirin. Burn off alcohol. Pour 100ml soy sauce, add 1/2 tspn sugar. Stir in 50g sesame paste and 50g peanut butter. Add 1 tspn sesame oil and allow to simmer for 2 minutes.

Burn alcohol off sake. Pour in 100ml water and bring to boil. Turn heat down. Add in 1 egg yolk and 100ml soy sauce. Dissolve 100g sugar. Stir in 150g white miso and let miso sauce cool.

150g White Miso Paste
100ml Water
1 Egg Yolk
100g Sugar
100ml Soy Sauce
30ml Sake

Miso Sauce

Ginger Sauce

4pc Lime
100g Ginger
1kg Onion
1L Soy Sauce
500ml Vinegar

Cut each lime into 4 pieces, take away seeds and skin. Cut 100g ginger into thin slices. Chop 1 kg. of onion and wash into a separate container until the taste disappear. Drain water. Mix all ingredients in a blender. Pour 1lt soy sauce and 500ml vinegar. Blend.

Mix 1 tbspn wasabi powder with water. Stir until wasabi powder turns into a paste. Next mix 120ml mayonnaise with wasabi paste. Stir again.

120ml Mayonnaise
1 tspn Wasabi Powder
2 tspn Water

Wasabi Mayonnaise

Yakitori Sauce

50ml Mirin
50ml Sake
1/2 cup Soy Sauce
1/4 cup Sugar
1/4 tspn Chicken Stock

Bring 50ml of mirin and 50ml of sake to boil. Light with fire and burn alcohol. Add sugar and stir until dissolved. Add chicken bone. Set to low heat for 20 minutes, stirring occasionally.

Finely chop parsely, set aside. Roughly crush pine nuts and set aside. Pour sesame oil into a warm pot then scoop smooth peanut butter, stir to melt. Once melted slowly stir in coconut milk until the peanut butter has mixed with the milk. Continue to stir. Mix light soy sauce then fish sauce. Last sprinkle parsley and crushed pine nuts with satay sauce.

10g Parsely
10g Pine Nuts
6 tspn Peanut Butter
1 tspn Light Soy Sauce
1/2 tspn Sesame Oil
150 ml Coconut Milk
1 tspn Fish Sauce

Satay Sauce

1 Lemon Juice
200ml Soy Sauce
200ml Vinegar
100ml Water

Ponzu Sauce

Mix soy sauce, vinegar, water in a container and stir well. Squeeze lemon juice through a filter keeping the seeds out. Stir.

Cut onion, celery, capsicum, ginger and garlic in rustic pieces. Mix in a blender with a quarter amount of soy sauce and water. Cover and turn the blender on until all ingredients are mixed. Pour mirin and sake in a pot and boil. Keep a fair distance and burn the alcohol off. Add the remaining amount of soy sauce and water into the pot. Bring to boil, then turn the heat to low level. Add sugar and stir until dissolved. Add remaining sauce from the blender and stir occasionally. Maintain a low heat to let the sauce thicken.

1/2 pc Onion
1/2stck Celery
20g Capsicum
20g Ginger
30g Garlic
50ml Sake
200ml Soy Sauce
20g Sugar

Garlic Sauce

Cleaning your teppanyaki table

s easier to clean the hot-
te on a low heat, the
tplate should not be dead
d, but just warm enough
 the water to run over the
te without boiling immedi-
y. Mix water with detergent.
rub the hotplate with a
er of griddle screen on the
ttom, a scara in the middle
d a cloth on top.

Wipe the table with a wet cloth
after scrubbing the hotplate to
bring the teppan back in its pris-
tine condition. Wiping the table
before and after each meal is
cooked keeps a hygienic table
and makes final cleaning easier.

Wipe the table with oil after
you have thoroughly cleaned
the residue off from your last
meal. This will prevent any
rust from forming when you
are not using it.

References:
Kazuko, Emi, 2002, Japanese food and cooking, Malone Margaret, Hermes House, London.
Kitao, Kathleen, History and Legend in Shimoda, Japan (Online), A vailable: http://muse2.doshisha.ac.jp/ kkitao/ japan/shimoda/s3.htm, [Accessed 11 May 2005].
Kusama, Shunro. 2000, The Beginnings of Western Food Culture in Y okohama (Online) , A vailable:http:/ /www. yoke.city.yokohama.jp/articles/00.08/ kusama09.html, [Accessed 2 December 2003].
Gifts of Nature and Port (Online), Available: http:// www.kippo.or.jp/culture/syoku/umiyama_e/ hyogo03_e.html, [Accessed 23 December 2005].

Printed in the USA
CPSIA information can be obtained
at www.ICGtesting.com
LVHW060222181223
766747LV00026B/1618